CLAUDE MONET

LIFE AT GIVERNY

overleaf:
Monet in a familiar attitude, dressed in country tweeds
and the ever-present cigarette in his mouth.

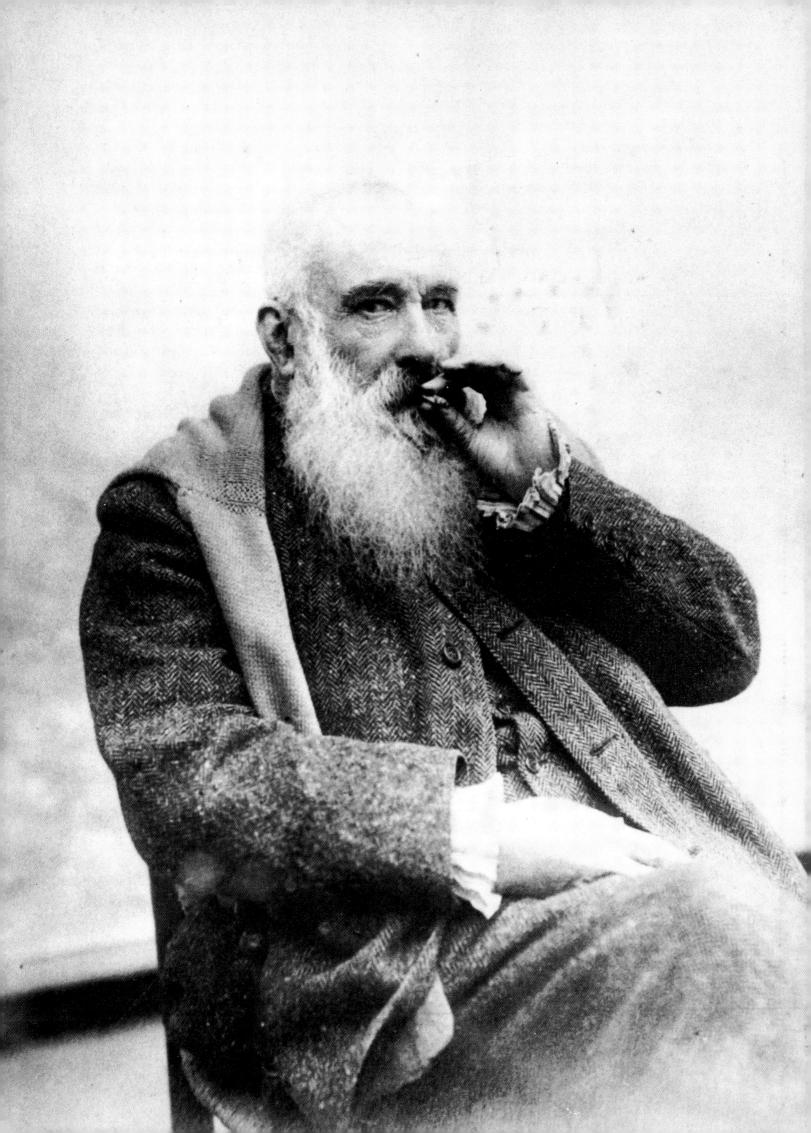

CLAIRE JOYES

CLAUDE MONET

LIFE AT GIVERNY

Preface
Gérald van der Kemp
Member of the Institut de France

Photographic and editorial research
Jean-Marie Toulgouat

Thames and Hudson

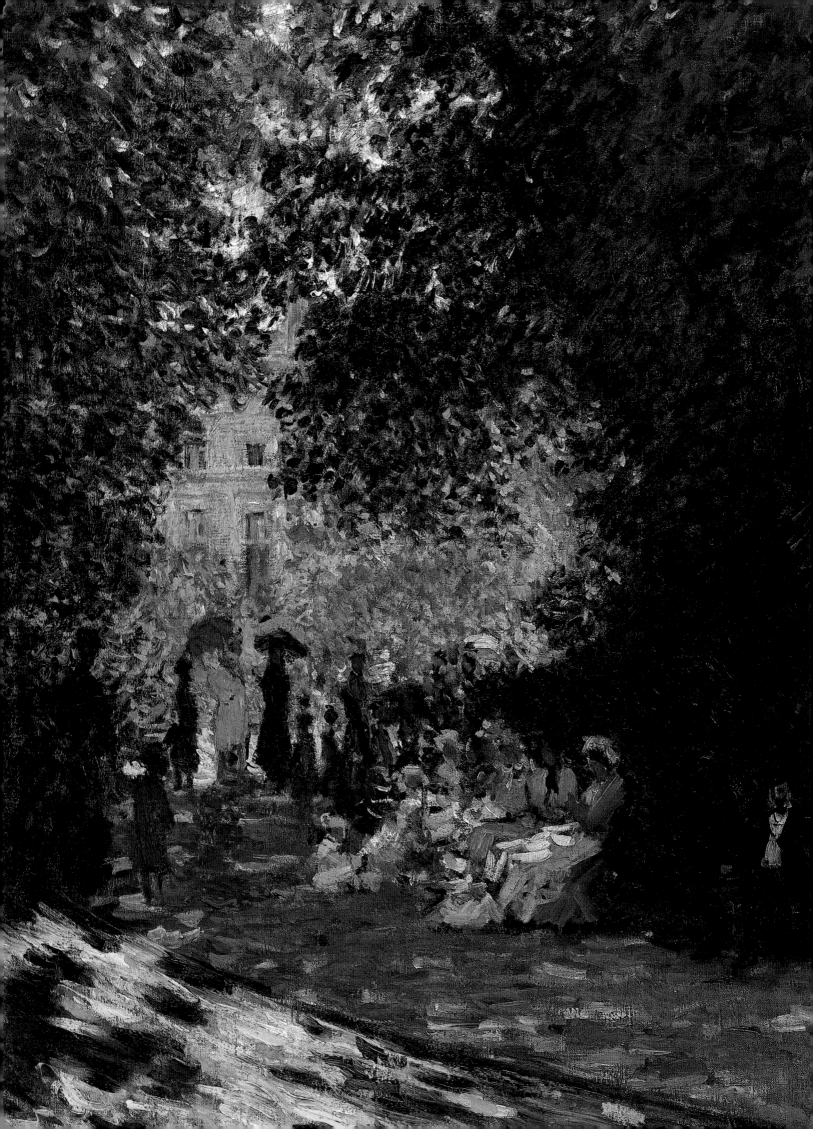

Contents

opposite: *Le Parc Monceau* (Parisians Enjoying the Parc Monceau).
1878. 28⅜ x 21⅜″ (73 x 54.5cm). Metropolitan Museum of Art
(Mr. and Mrs. Henry Ittleson, Jr. Fund), New York.

Monet at Giverny

It gives me great pleasure to make these introductory remarks about a beautiful book in which Claire Joyes has succeeded so wonderfully in telling the story of the celebrated gardens that the painter Claude Monet created in the years 1883–1926, lavishing on the project the whole of his love, care, and pride. Scarcely anything in life meant so much to him as his garden. Monet never, or rarely, spoke to his friends about his painting, but he always mentioned—and with great satisfaction—the latest events in his gardens!

By the beginning of the 20th century, Monet's gardens were already famous, and the few persons privileged enough to see them approached these horticultural marvels with something like religious awe, knowing they were the work of a master intent on delighting the eye. Now, however, these most private of gardens have become public, and the privilege of making them so—of restoring them to their original glory—has been mine.

After Monet died in 1926, his daughter-in-law, Blanche Hoschedé Monet, who was also his step-daughter, took beautiful care of the gardens for the rest of her life, which ended in 1947. Meanwhile, however, it was Monet's younger son, Michel, Blanche's stepbrother and brother-in-law, who had inherited the property. Michel Monet felt no particular attachment to Giverny, preferring, rather, to travel and to hunt in Africa. Thus, he built his own house some twenty miles distant from Giverny, and left his illustrious father's domain to be overseen by Blanche.

Thereafter, Michel Monet placed the house and garden in the hands of a caretaker, who gradually allowed everything to fall into neglect, with the exception of the central *grande allée*. Visitors to Giverny in those days remember the place with great sadness. In 1960, the eighty-two-year-old Michel Monet died in an automobile accident. By the terms of his will, the whole of the Giverny estate—the house, the furniture, the collection of Japanese prints, the master's unsold paintings— passed to France's Académie des Beaux-Arts, which appointed the architect Jacques Carlu, a member of the Institut de France, custodian of the Monet legacy. M. Carlu repaired the roof of the main house, but, for the want of funds, he could not prevent the deterioration of everything else. And so he transferred to the Musée Marmottan the whole collection of paintings, including those the master had received from his friends, but the property itself continued to decay. Following a long illness, Jacques Carlu died in 1977, whereupon the Institut de France asked me, as a fellow Academician, to see what could be done to salvage and restore Giverny.

Startled by the enormity of the task, I nonetheless agreed to attempt the impossible, moved by the fact that there no longer existed in France so much as a single residence, with its environment intact, that once belonged to a great artist.

The means the Académie and the Eure district authorities advanced toward the work soon melted away, like butter in the sun, and to continue restoring the gardens, the ponds, and, above all, the buildings, I needed a great deal more capital.

Earlier, my wife and I had created the Versailles Foundation in the United States to help finance the restoration and maintenance of Versailles, and, with the consent of Washington, we succeeded in having the name Giverny attached to that of the Foundation. By this device, Giverny has been saved. Needless to say, Claude Monet has always had an immense following in the United States. It began with the first exhibition of Impressionist works mounted in New York by the Parisian dealer Paul Durand-Ruel, the success of which formed the basis of the triumph that a fifty-year-

old Monet would experience somewhat later in Europe. Thus, it is in the United States that we have found the great friends of Claude Monet, still generous and now eager to help us, through our Foundation, restore Giverny.

The first benefactor was Mrs. Lila Acheson Wallace, founder of *The Reader's Digest* and one of America's leading philanthropists, and with her munificent contribution we got the renewal of Giverny off to a good start. Since then, many friends—from Texas, Florida, California, Chicago, New York, and France—have joined the movement, enabling us to undertake the restoration not only of the gardens but also of the buildings and furniture. The buildings, which comprise the house that Monet and his family lived in and the artist's studios, were falling apart with age. Most of the paneling and parquets had rotted, the furniture was broken and mildewed, and the artist's first studio resembled a jungle, with weeds pushing up through cracks between the floorboards. Not only did we have to redo the roughcast on the exterior walls, but we also had to rehabilitate all the interiors, recover their original colors and gaiety, repair the furniture and objects, remake the curtains, re-

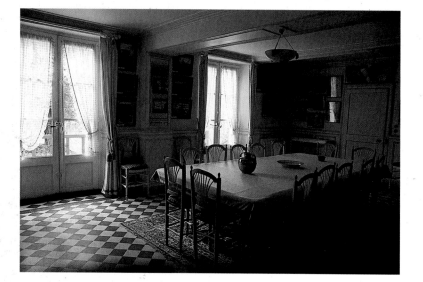

The two-toned yellow dining room and Monet's blue salon-library, after the Giverny house had been restored.

create the original materials used on couches and walls, restore the Japanese color woodcuts,* which also had been attacked by mildew, and rebuild collapsed stairs. The work went on for three years, and it became nothing less than a resurrection. The impact is now such that the visitor might very well expect the master to appear alive and still active in his own domain.

Next, we attacked the second studio, which too had fallen into decrepitude, its windows broken and the floorboards loose and damaged. But it was here that Monet had worked alone, denying admission even to his family. Once more in good condition, the second studio houses the offices of the Service de la Conservation.

The third studio, known as the "Atelier aux Nymphéas," is an immense building constructed at the instigation of George Clemenceau, France's fiery Prime Minister and Monet's best friend, between 1914 and 1916. It was here that the elderly Claude Monet painted what he called "the large waterlily decorations," a long serial masterpiece into which the artist poured the whole of his genius. He presented the most beautiful of these canvases to the French nation, which installed them at the Orangerie in Paris's Tuileries Gardens. The condition of the big studio being indescribable, suffice it to say that three trees had grown up inside! Thanks to the generosity of M. Michel David-Weill, we have been able to restore this superb structure in the most careful and authentic manner.

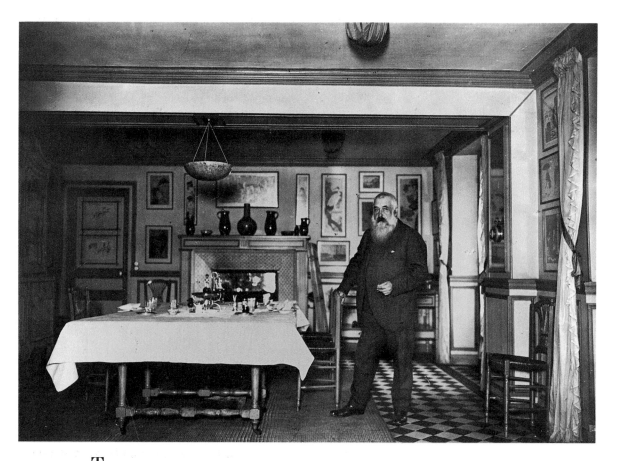

The dining room, with its painted furniture, its two-toned yellow walls, and its Japanese color woodcuts, framed in simple rush and hung in a rhythmic arrangement by Monet himself.

As the number of visitors increased, we found it necessary to purchase land opposite the Monet house and there make a parking facility landscaped with handsome trees, as well as build a large hothouse for the cultivation of the annuals needed in Monet's flowerbeds.

At the present, we are restoring three buildings that stood on land attached to the parking area. Once three-quarters ruined, these structures will eventually house a tearoom, a seed shop, apartments for the custodians, gardeners, and secretaries, as well as artists' studios, the latter designed to permit young painters to work at Giverny for a season free of financial concern. When finished in 1986, the facilities will provide great practical advantages for the whole Giverny complex.

In our restoration of the gardens and ponds, I have, without question, been immensely helped by Claire Joyes's research, but I must also admit to a life-long interest in flowers, which led, following World War II, to four years of evening classes at the École Nationale d'Horticulture in Versailles. There, I came to know many botanists, and the experience has brought me into a long and close relationship with M. André Deviller, botanist emeritus and former general director of the Établissement Georges Truffaut, the famous nursery in Versailles that traces its origins all the way to the 18th century.

During the First World War, André Deviller became a very young deputy to M. Georges Truffaut, and for several years he made a weekly visit with his employer to Giverny, where the two men joined

Monet over lunch while discussing the seeds and flowers the artist wanted to plant. When M. Deviller heard of our plan to restore Giverny, he caught fire and, despite his great age, offered to help us in every way possible to give the master's gardens their true original appearance. Thanks to him, therefore, we have even been able to bring the color scheme very close to the flowered palette favored by Monet himself.

After tearing out nettles and brambles and cutting down dead trees, we ploughed the grounds to find the gravel identifying the paths laid out by Monet. We added new top soil to countless flowerbeds and then replanted the gardens exactly as Monet had done, so that from spring to autumn we now have an uninterrupted succession of blooms. We also restored the pyramidal and arched metal trellises, as well as the rectangular latticework, all for the climbing roses and clematises. We have also rebuilt the small hothouses next to the second studio, where we now grow, just as Monet did, the orchids that adorn the house during the visiting season.

At the bottom of the main garden was a narrow twisting road—le Chemin du Roy—flanked by a tiny local rail line. Alas, by the time we arrived, both the road and the rails had been destroyed and replaced by a major thoroughfare. To overcome this obstacle set up between Monet's principal flower garden and the water garden, we have, with the generous financial support of Ambassador Walter Annenberg, dug under the highway and built a tunnel embellished with trellises, a facility that now provides direct access to and from the key parts of what one art historian has, unforgettably, termed "Monet's harem of flowers."

We have also restored the Japanese-like water garden, which proved to be a costly undertaking. Since the famous Japanese bridge and the pumice stones supporting it were rotting in the water, we decided to replace them with exact copies. The pond was full of black water, polluted by effluents from factories upstream. To restore its freshness, we had to dig wells all the way to ground water and there tap the pure sources that now feed the pond. But the pond had also been invaded by guinea pigs, pests stupidly set free by a farmer when the Germans occupied Normandy. Millions of these rodents now infest the rivers of Europe. Because of the tunnels dug by them, nothing could be planted along the edges of the pond, nor could lilies be placed on the water, since their roots would have been immediately devoured! Thus, we had to line the pond completely around its edges with sheet metal sunk into the mud, which now prevents the guinea pigs from digging tunnels and living off the pond. The little animals have been forced, willy-nilly, to find their way back to the river. Finally, we have been able to replant even in the water garden, along whose banks now flourish the trees, bushes, and flowers that gave Monet such pleasure throughout his later life.

And so, it is not only the house, the studios, and the flower gardens, but also the lily pond and water garden that today evoke the living presence of the master, body and spirit alike. I would even venture to suggest that to have a truly thorough understanding of the oeuvre of Claude Monet, to know his mind and the sources of his imagination, to feel him still living among us, it has become essential to make a pilgrimage to Giverny.

<div align="right">

GÉRALD VAN DER KEMP
Honorary Chief Curator
Musée National de Versailles
et des Trianons
Honorary Inspector General of Museums
Member of the Institut de France

</div>

The forty-six unsold paintings by Monet and the several paintings by the artist's fellow Impressionists that remained at Giverny when Michel Monet died can presently be seen at the Musée Marmottan in Paris.

Now returned to Giverny are the Japanese color woodcuts that Monet began assembling in 1870 and continued to collect for the rest of his life. These remarkable works hang precisely where they did in the artist's time, and they are of a quality to interest not only connoisseurs of Japanese printmaking but also those who love French Impressionism, that school of painting which revolutionized the entire formal character of the Western plastic arts.

Monet formed this collection with love, a love and an interest that cannot but reveal the extent to which the Japanese print and the new vision it represented engaged the passions of the entire Impressionist circle. What wouldn't we give today to have a catalogue of the prints once owned by Millet, Manet, Degas, Whistler, van Gogh, and Rodin! All of these collections have been dispersed and lost track of. Only that of Monet remains generally intact.

In their woodcuts—an art form they call Ukiyo-e or the "Floating World"—the Japanese attempted to capture an immediate impression of the everyday environment. With its endlessly repeated images of day, night, rain, snow, the seasons, this is indeed a floating world, in principle very much like that of Monet, who endlessly returned to the same subject, under different conditions, in his various series—flooding along the Seine, mornings on the river, poppy fields, haystacks, Rouen Cathedral, rows of poplars, views of the Thames, and, finally, the brilliant, twenty-year obsession with waterlilies, perceived in the morning, at noon, at dusk, in every kind of weather and by whatever light the sun, wind, or clouds might bring.

In this encounter between two aesthetic systems, something more than the merely fortuitous emerges once we consider the new Japanese-inspired way the Impressionists approached matters of composition. Like the Japanese, Monet and his friends wanted their brushwork to be as fleet and deft, their drawing as simplified, their colors as fresh, and their palette as limited as a first impression. In Japanese art we find analogues for Monet's rapid, febrile stroke, Degas's daring compositions, with their high vantage point, and Manet's flat fields of color, the latter very much in the vein of images d'Épinal.

All these great painters freely admitted that their discovery of Japanese prints helped them to escape from the strictures of worn-out conventions. Of course, they filtered that influence through their own Western sensibility, but the fact remains that Japanese art, with its instantaneity, spontaneity, and surprise pointed the way to new horizons. Thus, the color woodcuts of Japan are perfectly at home in the house at Giverny, where for forty years they served as a constant source of inspiration to Claude Monet. The Japanese bridge, the bamboo grove, and the lily pond are living proofs of it.

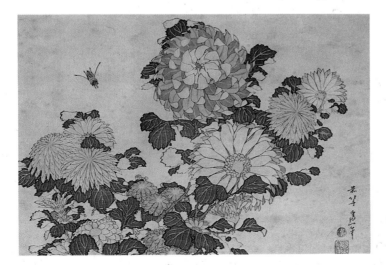

A print from Monet's collection of Japanese color woodcuts: Hokusai, *Chrysanthemums and Bee,* one of ten works from the *Large Flower Suite.* Monet lamented the fact that he did not also own *Poppies* from the same series.

opposite: The two dressing rooms in the suite occupied by Claude and Alice Monet. The walls were once covered with paintings by Cézanne, Pissarro, Sisley, Renoir, Corot, and Delacroix, among others.

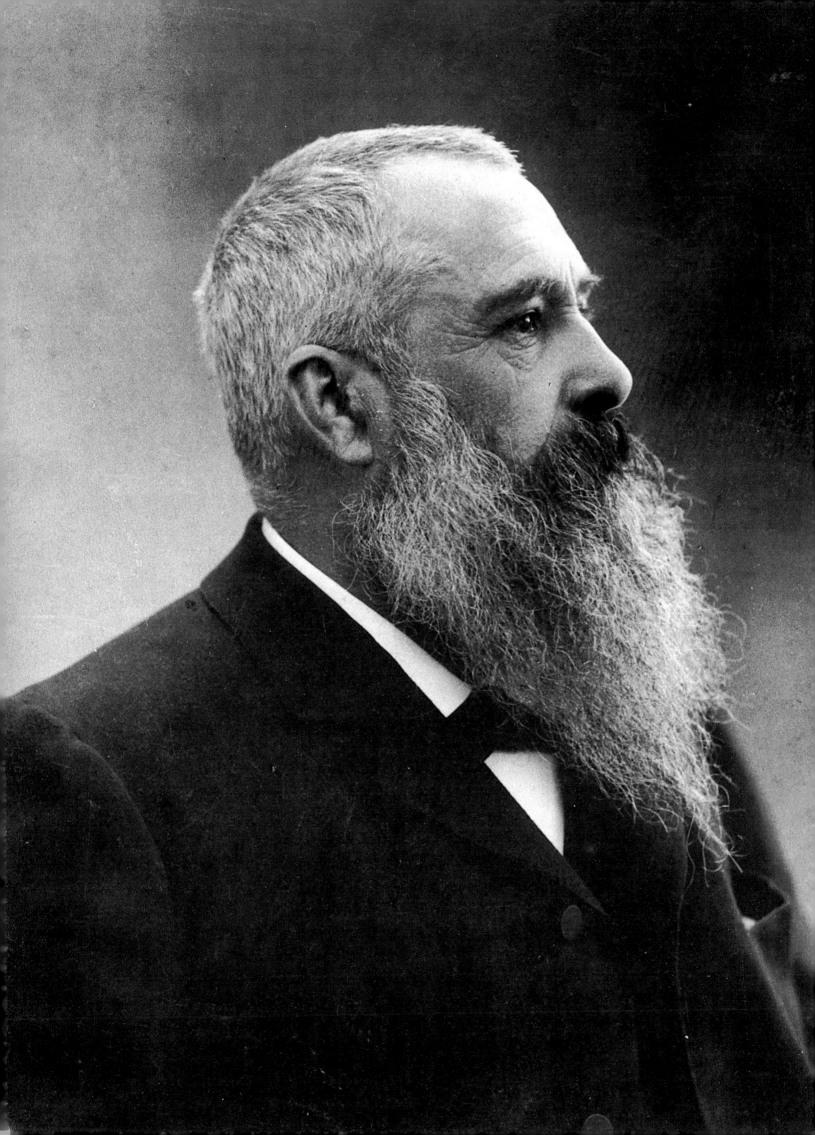

Summer at Montgeron

The Giverny story had its beginning in the summer of 1876, when Claude Monet paid his first visit to the Château de Rottembourg, the country estate of Ernest and Alice Hoschedé at Montgeron in Normandy. Summering with the Hoschedés could be delightful, thanks to hosts whose considerable means, squads of discreet, efficient servants, and longstanding convictions enabled them to live as freely as the period's unwritten but precise codes allowed. A curious mélange, their lifestyle consisted of lavish entertainments and charitable works, avant-garde patronage, worldly ways, and religious fervor. Ernest and Alice Hoschedé came from different milieux, although both were Belgian by birth. Ernest belonged to a high-bourgeois family, with wealth made in the textile trade during the Second Empire, and had now become the director of Hoschedé-Tissier, Bourély & Cie, a firm with holdings in the fashionable Parisian department store Au Gagne-Petit. Alice's family, the Raingos, dealt in bronze objets d'art and had been suppliers to the Imperial household, while another branch of the clan enjoyed a pan-European reputation in horology. For all these reasons, the Raingos were not only rich and sophisticated; they had also emerged as the "locomotives," or leaders, of Belgian society in Paris.

Ernest Hoschedé—to whatever extent his business responsibilities permitted, which, to the despair of his family, was very little—indulged his passion for collecting pictures. Not only was he an enlightened connoisseur, but he also eagerly assumed the Maecenas role of generous patron. Moreover, he chose well and paid well, without waiting until the Impressionists had been critically canonized before acquiring their work and cultivating their friendship. Indeed, Ernest Hoschedé had the gifts of a talent scout, with an innate sense that would have made him an extraordinary art dealer rather than the ordinary businessman he was. Happily, Alice fully shared her husband's taste for painting as well as his love of associating with artists, writers, and musicians.

At a time when everyone was trying to forget the Franco-Prussian War and its dreadful aftermath, the holidays unfolded at Rottembourg in a sweet succession of halcyon hours. As white turkeys pecked their way across the park, visiting artists took up their brushes in studios fitted out by the host so that he could truly play the munificent patron. Also present were fine old nannies to spend the afternoons under shade trees telling cheerful tales to five children who seemed beyond the reach of all trouble.

Every day was special at Montgeron, where the Hoschedés received an endless stream of guests. Sometimes they arrived by special train from the Gare de Lyons to attend parties of the most brilliant sort. During quieter intervals Ernest and Alice entertained their artist friends, a few at a time. In Paris as well as at Montgeron, it was talent, much more than high social status, that counted with the Hoschedés. Regular visitors to Rottembourg included the Carolus-Durands (actually country neighbors), Louis Baudry, Jean-Jacques Henner, and the publisher Georges Charpentier and his wife. Even the retiring Alfred Sisley made an appearance at Montgeron. Édouard Manet and his wife also stayed there, becoming great favorites with the children, whom the illustrious visitors spoiled outrageously. This was especially true when Suzanne Manet played the piano in the evening, an event for which the young were permitted to stay late. Manet, meanwhile, amused his hosts with the most astonishing questions about country things.

At Rottembourg one met both landscape painters, enthusiasts of working out of doors, and portrait painters, who felt more at home inside. The two factions would then come together at dinner,

Claude Monet, by Paul Nadar.

during their long walks, or in one of the salons. Occasionally one portraitist sat for another, which required that the favor be returned. It all managed to be such fun that artists who had come in order to work in peace imagined themselves finally complaining of all the distractions they found in the country.

One day in July 1876 Ernest Hoschedé announced that he had invited Claude Monet to come and paint. If Hoschedé had already bought paintings by Monet, he probably had done so through dealers or at auction. The two men knew one another only slightly, Monet having never been part of the Hoschedé circle. But even though somewhat unsociable by nature, the painter could not refuse an invitation from a host whose graciousness had become proverbial.

The children were on the *qui vive* for the arrival of a new guest already characterized as someone out of the ordinary. Known to a few initiates, but generally derided, Monet at that moment was leading a very difficult existence. In the 1870s there could be little hope for a painter excluded from the Salon, where Monet had enjoyed acceptance only on two occasions, once with *Road in Fontainebleau* (1865) and then again with a portrait of Camille Doncieux (1866), the artist's future wife. But while these pictures had received much attention, especially from the novelist Émile Zola, then a practicing art critic, the large *Women in the Garden* (1867), as well as a number of other innovatory works, suffered rejection, and after 1869 Monet saw little chance that his newer paintings would find official favor.

At Rottembourg, Monet worked assiduously, but then, at moments of relaxation, he could join the others in easy conversation cradled in an atmosphere of secure well-being. Hoschedé purchased several paintings from Monet, something he did not invariably do with his painter guests, and also commissioned four pictures as decorations for the salon, works that much later would be known as the *Montgeron Decorations*. Required to work from subjects truly symbolic of what Rottembourg stood for, Monet chose the pond at Montgeron, a corner of the garden near the pond, the white turkeys in the park, and, later, the hunt. When the visit came to a close, all agreed that the time had gone too quickly and promised to see one another again. No one could have imagined that a relationship begun only a few weeks earlier would become paramount to each of them for the rest of their lives.

Come the autumn, when the bustle of Paris recommenced, the two families began to see one another quite often. Monet and his wife, Camille, received the Hoschedés in their studio, while the latter continued along their carefree way, throwing one party after another. That year they gave a costume dinner, at which Mme Charpentier wore a mask painted by Renoir, who, as always when with Monet, joined his friend in the wildest pranks, which on this occasion meant making themselves a pair of ghastly heads—covered with boils!

For the five Hoschedé children and Jean Monet there were also afternoons in the Parc Monceau, where the shared joys of childhood formed the beginning of what circumstance would transform into indissoluble ties.

Soon, however, this idyllic existence would be replaced by a brutal torment, the likes of which no one could possibly have foreseen, except Ernest Hoschedé, whose business affairs had been going badly for some time. Hopeful of eventually rectifying the situation, he concealed from his wife the gravity of the developments. Actually, for the second time in two years the good man was threatened by his partners with relegation to the position of a minority shareholder. Finally, the inevitable happened: Hoschedé slid into bankruptcy.

Early in the summer of 1877, when summoned by his associates, Hoschedé failed to appear and, without a word, abandoned his family and home. A friend he happened to meet kept the desperate man from committing suicide and undertook to accompany him to Belgium, whence Mme Hoschedé received a letter that suggests the degree of her husband's frantic confusion: "My beloved wife!" he

wrote, "what can I call, what may I call you now?... I struggled like a giant for a whole month.... I lost my head.... I wanted to kill myself.... I can't stay in Paris. Am I to go on living for your sake and that of our beloved children?... Don't curse me.... Tell me to take heart or tell me to disappear.... Let no one try to find me, or I shall kill myself...."

As her protected, privileged world suddenly collapsed, Alice Hoschedé found herself deserted and alone with five children and another on the way. Both the partners and the creditors of Au Gagne-Petit were adamant in insisting upon their rights and thus claimed all the Hoschedés' remaining assets, even the Château de Rottembourg, Alice's own personal property. After the furniture had been seized, the art collections were consigned for auction. As if this were not enough, poor Alice had to help prepare the inventories of her beloved possessions, and then watch them be tossed in willy-nilly with the wreckage from countless other shattered fortunes. When the court-ordered auction occurred, the gavel fell on some fifty Impressionist canvases, including works by Manet, Renoir, and Sisley, as well as twelve important pictures by Monet, one of them the famous *Saint-Germain l'Auxerrois*. All went for absurdly low prices, only to become the glory of the museums where they would eventually hang.

Alice, of course, lost all her servants, all, that is, but one devoted maid, who refused to abandon

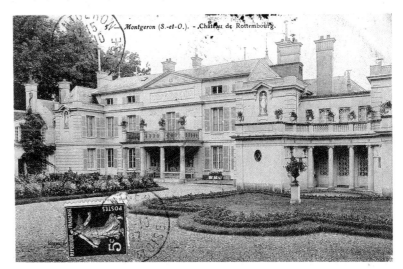

On the outskirts of Paris, the Château de Rottembourg, where guests sometimes arrived by special train to attend grand parties given by Ernest and Alice Hoschedé.

Mme Hoschedé and remained with her as an unpaid companion. Accompanied by this selfless woman, Alice and her five children set out for Biarritz, there to stay with her sisters. The journey took a most dramatic turn when the train had to be halted long enough for Alice to give birth to her sixth child. Thus did Jean-Pierre join the family, as a disbelieving station manager minded the newborn's older siblings in a neighboring compartment.

At Biarritz the family held council and decided to make Alice a small allowance, largely to permit the children to live decently and be educated. Once returned to Paris, Alice had her first true taste of poverty. To relieve the financial stress, she gave piano lessons and did a bit of dressmaking for her friends.

In the meantime, Claude and Camille Monet were going through an unimaginably difficult time. Monet's art was still misunderstood, and no help was to be had from the relatives of either the painter or his wife.

In 1878, after Rottembourg had been lost forever, Monet and Mme Hoschedé decided to make common cause and move their families to the country for the summer, sharing a house in the village

17

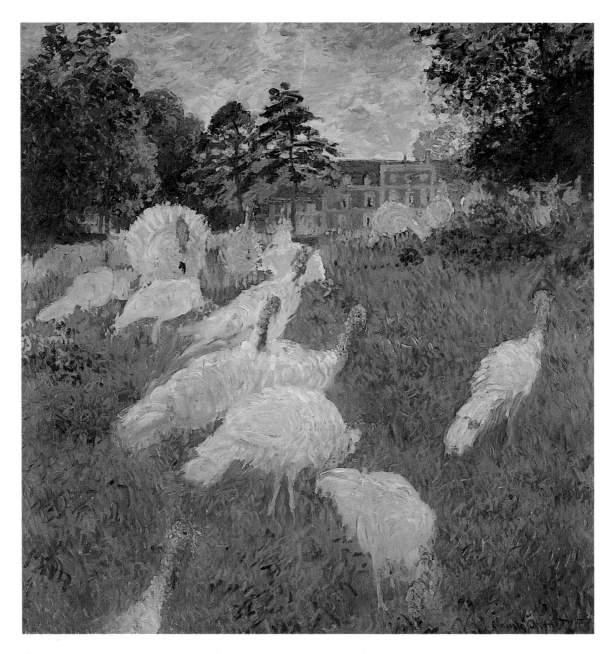

Les Dindons (The White Turkeys). 1877.
5′7″ x 5′9″ (172 x 175cm).
Galerie du Jeu de Paume,
Musée d'Orsay, Paris.

opposite: *La Chasse* (The Hunt). 1876.
5′8″ x 4′7″ (173 x 140cm).
Collection Durand-Ruel, Paris.

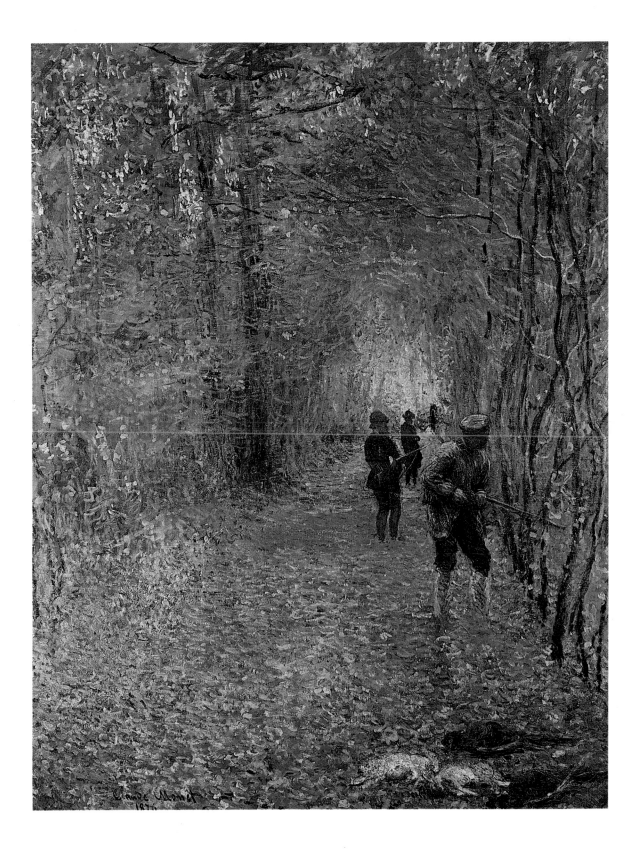

of Vétheuil. But instead of a few months, they would remain three years. Quite apart from the fact that it cost less to live in the country, Monet discovered a wealth of motifs in the Vétheuil region of the Seine Valley, and whenever a site inspired him, he worked it to the point of exhaustion. It was at Vétheuil, for instance, that a brief winter thaw, lasting only a few hours, enabled the artist to produce the series entitled *The Break-up of the Ice.*

Affluence may attract a good many friends who may or may not endure in times of financial ruin or economic hardship. Thus, it was all the more important to keep up appearances, and to do so, as a friend of the Monets and Hoschedés would recall years later, Camille and Alice took turns going to Paris, since only one truly elegant dress hung in the closet at Vétheuil. By now the families had passed from poverty into destitution, and even the children had to share whatever presentable clothing they owned. Alice found herself attacked by an unpaid grocer, and Monet had to barter a picture for a pair of boots. He even left paintings as guarantees to tradesmen.

During the Vétheuil period Claude and Camille Monet had a second son, Michel, whose mother would fall gravely ill shortly thereafter. Although 19th-century medicine could probably have done nothing to save her, it seems certain that the privations suffered by Camille contributed to the decline of her health. She died in September 1879, when Michel was two years old.

A dazed and desperate Monet left his children to the care of Alice Hoschedé, who proceeded to bring up Jean and Michel with her own brood of six: Marthe, Blanche, Suzanne, Jacques, Germaine, and Jean-Pierre. A deeply sensitive woman, with mystical tendencies, Alice transformed her genteel upbringing into great personal strength and showed remarkable dignity in the face of marital and financial humiliation. With Hoschedé more in Paris than in Vétheuil, and evidently incapable of taking responsibility, Alice marshaled her resources and launched upon the task of building a new family life on the foundations of two shattered homes. This entailed not only the education of eight children but also the encouragement and sustenance of Monet himself, in whose artistic genius Alice believed.

For the sake of the older children's schooling, the Monet-Hoschedé household left Vétheuil for Poissy, where Monet, however, had difficulty working. The landscape, the light, and the two houses they tried living in proved unsatisfactory from the painter's point of view. Summer, therefore, brought a further move, this time to Pourville by the sea, which seemed a more promising locale for landscape painting. Luckily, the Poissy lease expired in April, and, even without knowing where to alight, Monet rejoiced at being free to escape "that horrible Poissy." What he longed for was a village well away from Paris, but not too remote, and a decent house in which he could feel settled for a bit.

Irresistibly drawn to the Seine Valley, Monet remembered the district around Vernon and the little villages he had encountered earlier in the course of rambling walks and boat trips down the Seine from Vétheuil. In April 1883, as he sat in the train winding its way along the river's edge toward Vernon, Monet no doubt brooded on his recent misfortunes. Among them would have been the summer at Pourville, where wretched weather frustrated his attempts to work *plein air* and forced him to remain indoors at the "villa Juliette." During this entrapment he struggled with still-life pieces, only to scrape them down and ultimately destroy the canvases. Then there were the two successive moves at Poissy, in addition to the rise in water that caused the Seine to overflow its banks, with the most appalling consequences to Monet's life: "I've now ceased being a painter," Monet wrote to Durand-Ruel, "only a lifeboat-man, a ferry man, a removal man, etc., ... We are literally under water...." The enraged artist went on, "I can't even think of painting, and yet there are things fascinating enough to paint...." The servants having fled in panic, Monet helped Mme Hoschedé deal with flooding so severe that they had to open the downstairs doors and let the water circulate freely. The sole safe haven was upstairs, since the house could be reached only by boat. Then, having lost

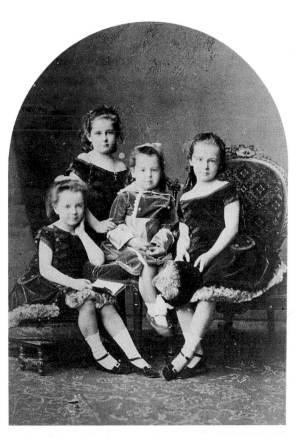

The four Hoschedé girls (from left to right): Suzanne, Blanche, Germaine, and Marthe.

below: Alice and Ernest Hoschedé, collectors and patrons, carefree and lavish. In 1878, the final sale of their possessions, following Hoschedé's bankruptcy, included some fifty major works by the Impressionists.

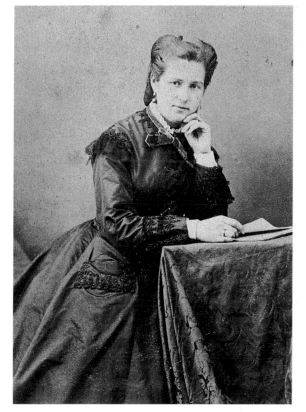

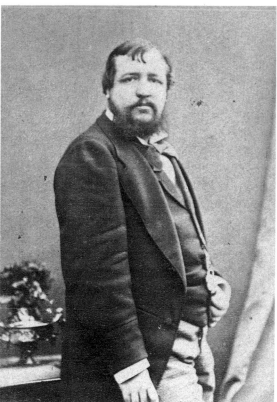

all this precious painting time, Monet could fret about the indifferent reception recently given to his first one-man show, which had opened on February 15 at Durand-Ruel's. Deeply wounded, he considered the exhibition a total flop—*un four complet*. Now if he found nothing to rent, Monet would have to face hostile landlords and negotiate an extension of the Poissy lease in order to save his family from being thrown out on the street.

At Vernon, Monet took a little train on the Pacy-sur-Eure line to Gisors that served the villages along the Epte River. The train was slow and stopped everywhere, even in the open country, to take on a local wedding party, which, to Monet's stupefaction, came aboard and settled in noisily.

It would require several excursions via that little train and a minute search of every village before Monet, just short of desperation, would return to Poissy with cheering news. Now, he had only to organize the move, an event that went on for ten days. All the while that he was making repeated round trips between Poissy and Giverny, neck-deep in parcels, Monet had also to take care of moving his boats. On April 29 he departed for Giverny with several of the children. The others had to be left behind with Alice, because at the last moment, for the want of cash, they could not take the train, even though the Poissy premises were to be vacated by ten o'clock the following morning. After a telegram to Durand-Ruel brought the necessary bit of money and thus resolved the crisis, Alice Hoschedé and her brood finally left to join Monet, no doubt forgetting the morning's misadventure before the little train had journeyed far along its twisting, narrow-gauge route.

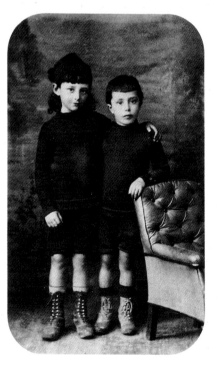

The two youngest children: Jean-Pierre Hoschedé and Michel Monet, at the time of their arrival in Giverny.

iverny

On either side of the Seine, a rather broad flow at this point, the hilly countryside would have been alive with new May growth, densely agricultural on the north bank and wooded on the steeper southern side, where a light, bluish haze gathers in late morning. Vineyards and flourishing orchards run down the slopes, as fallow trees encircle wide valleys awash in waving, flower-studded grain fields. Here and there a cluster of pines, torsioned and bent by the wind, signals the top of a lower hillock, the contours of its slopes rutted with roads halfway up. In the cradle of the valley run the Rû and Epte rivers, the latter a narrow channel that serves as a dividing line between two provinces: Normandy and the Île-de-France. An occasional meandering line of willows and poplars betrays the course of some tiny tributary. No real flatness or barrenness anywhere, only a gentle bosky wildness and ripe abundance.

Between the water and the hills stands Giverny, which instead of huddling close to the normally dominant church, sprawls lengthwise, its generally low houses roofed in small, brown, often mossy tiles and surrounded by gardens and cultivated fields. At the very heart of the village, tough, thickset hedges define and jealously guard the individual plots. As in all great river valleys, the light is soft and quick to change, sharpening outlines or blurring shapes, ceaselessly altering the look of things.

A few hundred meters from Giverny station, in a part of the village known as the Pressoir, or "Cider Press," stood Monet's house, a rather homely, unpretentious dwelling whose bourgeois character bothered neither the painter nor Alice Hoschedé, accustomed though the latter had been to the grand scale of a château and the rich, labyrinthine apartments of the Second Empire, rather than to the cramped suburban villas and meager gardens that came with bankruptcy. Located between the Ruelle Leroy and the Rue de l'Amiscourt, the structure the Monets and the Hoschedés were moving into resembled none of its neighbors. It was a long, somewhat tall building with pink roughcast walls, gray shutters, and a low barn at either end. The place had belonged to rich tradesmen from Guadeloupe, and while not totally at odds with a setting already quite Norman in character, the pink roughcast under the often wet northern sky, like the slate-covered roof ornamented with a small central pediment pierced by an oeil-de-boeuf, may have reflected some vague nostalgia for tropical islands.

The garden was a vast walled space, taken over in part by an orchard and otherwise a slightly prim affair absurdly ornamented with clipped boxwood, which Monet and Alice abhored. Two rather long

stiff flowerbeds, running parallel to a broad central *allée*, bordered, somewhat funereally, in spruce and cypress, descended along a gentle slope all the way to the Chemin du Roy. Beyond lay lush, perennially verdant meadows, waterlogged, thick with flowers in spring, and surrounded by the ever-quivering foliage of willow and poplar. But only the lime trees at the main door and a pair of yews at the top of the central walk held any value for Monet and Alice. On the whole, the garden was of a typical bourgeois provinciality, unimaginatively laid out and devoid of botanical interest.

While everything outside would have to be turned upside down, with whole masses of earth and plantings moved, in order to make a garden, the large house proved to be just about right for the Monet-Hoschedé mob, who quickly crowded into every nook and cranny. Meanwhile, Monet pushed his cases packed with paintings into the western barn, through its carriage entrance and onto a floor of impacted earth. The artist had chosen this space as his studio, probably because its windows provided a grand southern exposure to the garden outside. Beyond this lay the shaggy, refulgent landscape, which could hardly have been more seductive, its charm reinforced by the little train that

GIVERNY, près Vernon (Eure). — Etablissement Féron.　　　　·Edit. Petit. — Cliché Chardin.

GIVERNY (Eure) - L'Epte et les Pâturages

passed six times a day along the opposite side of the Chemin du Roy. It seemed centuries ago that Monet had written to Mme Hoschedé: " . . . in order to flee that horrible, unhappy Poissy, I'm prepared to do anything."

Hardly had Monet and Alice surveyed their new domain when, in shock and grief, they had to rush off to Paris. A telegram arrived informing them that Édouard Manet had died, and Eugène Manet, the artist's brother, desperately wanted Monet to serve as one of the pallbearers.

Even though launched under saddened circumstances, life at Giverny would soon take shape and find its daily routine. With summer near, Monet was eager to get kitchen and flower gardens into the ground. It was urgent that the latter be taken care of if there were to be cut flowers to paint on days when bad weather would keep the artist indoors. Organizing a garden was nothing new for Monet, who remembered the years when he and Renoir had sowed themselves a potato patch.

The harvest from the orchard would be bountiful, submerging the family in quantities of delicious fruit, and when the bottled sweets of every color had been stored away for winter consumption—the plums in homemade brandy—the children took charge of selling the surplus.

For the flower garden, Monet and Alice had already developed a few ideas. Everyone agreed that the clipped box should go, but tremendous arguments broke out over the spruce and cypress trees, quarrels that would go on for twenty years. And so Caillebotte would be asked to give an opinion when he came for a visit, and properly so, since it was he who, at Argenteuil, had first aroused Monet's lifelong passion for gardens. Together the two painters were insatiable on the subject of gardening. Caillebotte soon appeared on board his yacht, the *Casse-Museau*, and on its way down the

Seine, Monet joined his friend at the lock. He remained on board several days to paint, and then the two men went ashore to call on Octave Mirbeau, who had just written Monet a characteristically whimsical letter: " . . . I'm glad you're bringing Caillebotte. We'll talk gardening, since art and literature are nonsense. Earth is the only thing that matters. Even a clod of earth fills me with admiration, and I can spend hours staring at it. And humus! I love humus like a woman. . . . "

To begin painting again, Monet needed his studio-boat. Apart from the bare necessities and a few

At the foot of the hills, the Giverny house with its walls still bare and set beyond a large orchard on a gentle slope, which Monet would transform into a resplendent garden with the most astonishing color harmonies.

pieces that had escaped the various seizures, Monet and Alice had little furniture, but they owned no less than four river craft: a boat reminiscent of the *Bottin* Daubigny used as a studio, a rowing boat known as a *norvégienne*, and two mahogany skiffs.

Flowing across the meadows, behind the Ajoux field, the Epte empties into the Seine at a point where the great river played host to a sprinking of small islands. Among them was the Île aux Orties (Nettle Island), where Monet, with the help of his boys, moored the boats to the thick trunks of willow trees with long branches trailing in the water. It was their first outing, and after returning home at dusk, they could still hear, until nightfall, the noise of the little steamboats towing the Seine barges.

In this exquisite environment, which seemed made for going to sleep while watching the moon rise behind the poplars, above the Ajoux, Monet could even be soothed into believing that at age

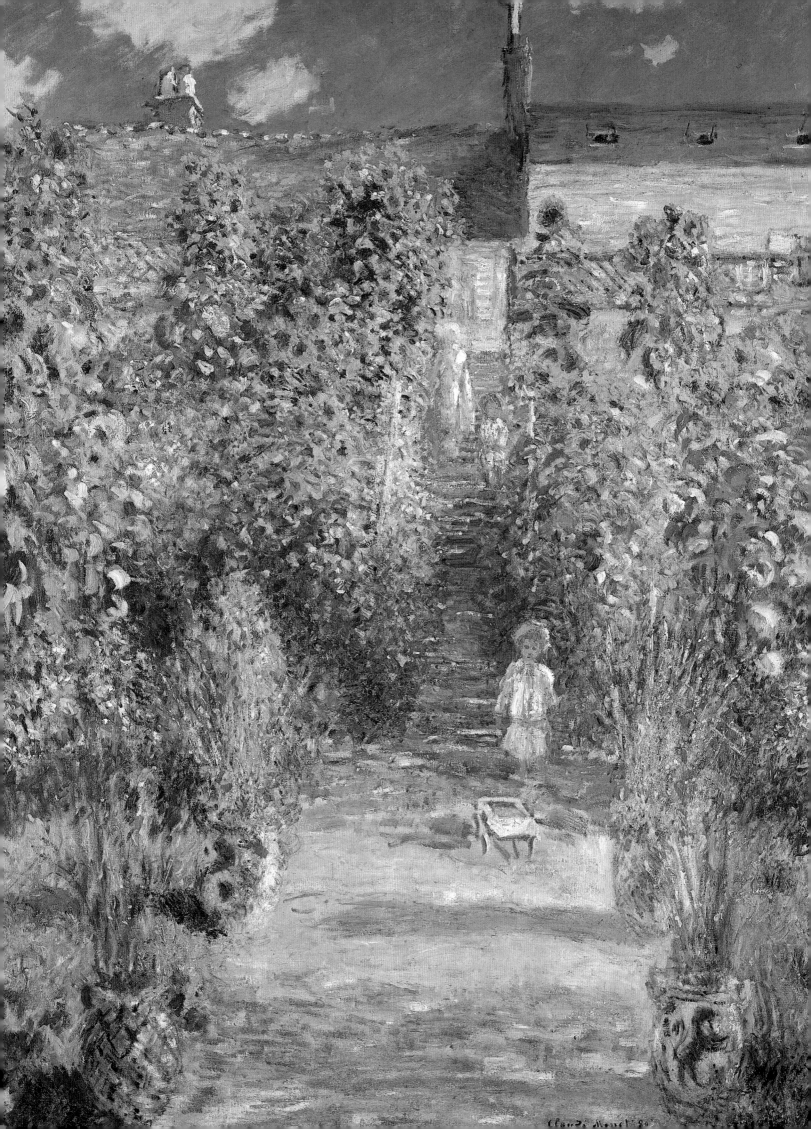

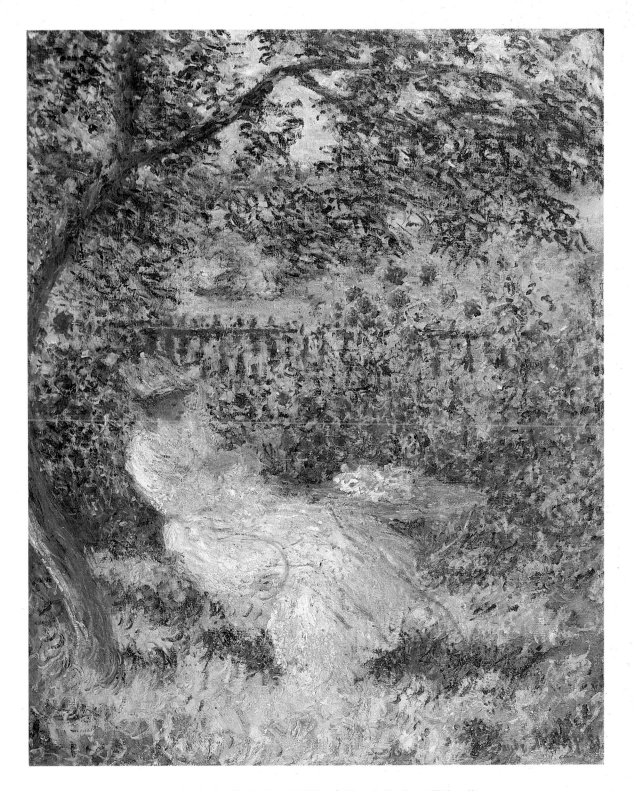

opposite: *Le Jardin de Monet à Vétheuil* (Monet's Garden at Vétheuil).
1880. 4′11⅝″ x 3′11⅝″ (150 x 140cm).
National Gallery of Art, Washington, D.C.

above: *Alice Hoschedé au Jardin* (Alice Hoschedé in the Garden).
1881. 32 x 26″ (81 x 65cm).
Collection Mr. and Mrs. C. Douglas Dillon.

forty-three things might at last begin to take hold—if only he were not so beset with financial worries and could free his mind of all but painting.

The artist and his family were enchanted by their gradual discovery of the village, with its place names unchanged since the Middle Ages—Pressoir, Chenevières, Rue aux Juifs, Rue des Chandeliers, Rue Messire Jean Coulbeaux, Chemin de la Disme—which spoke at every point of Giverny's ancient attachment to the Abbey at Saint-Ouen in Rouen.

During May, when the hay had yet to be cut, walks in every direction were beautiful, and the

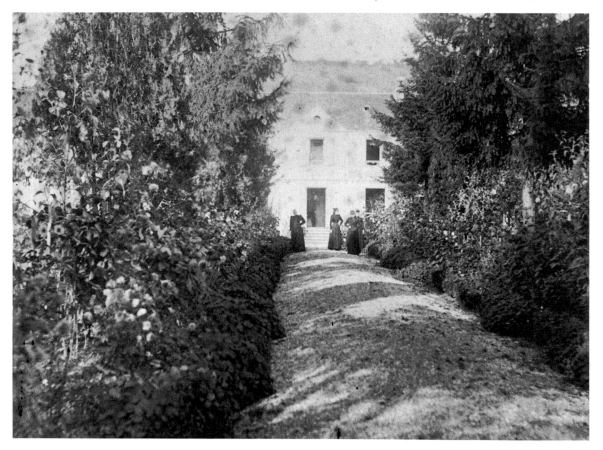

In the spruce-lined *allée*, leading to the house with walls the color of brick dust, Mme Hoschedé and three of her daughters. c. 1892.

family began picnicking in the hills, a habit they would keep for the rest of their lives. They climbed and stopped along the contour paths, known locally as *rouillières*, or went all the way to the plateau from which they could look down on the Seine in the full expanse of its water.

The Givernois were mostly peasants who, while showing no open hostility, fully expected to be paid a fair price for their favor. As in every village, Giverny had its characters: the traditional idiot, the inveterate poacher, a beggar woman who was not all that poor, a half-mad troglodyte witch who lived, of course, in the hamlet of Falaise.

Baffled by a family that were bohemian in appearance only, the Givernois distrusted those eccentrics who resembled no one else, neither country folk nor gentry. There were the girls, for instance, dressed in bright colors matched by an endless succession of parasols, and also the boys who

went about in pale pink hats (actually felt forms bought by Monet from a hatmaker who was going out of business). Only Mme Hoschedé, in her foulard dresses and muslin *polonaises* worn over sober skirts of solid color, impressed the villagers as obviously respectable.

The local population clearly did not think painting a proper occupation for a man. Moreover, they actually disliked Monet, who, reserved by nature and little given to casual conversation, seemed proud and aloof, despite his taste for sabots and berets. Too shrewd to be hateful, the Givernois simply claimed compensation from him under the vague pretext that the family, in their single-file

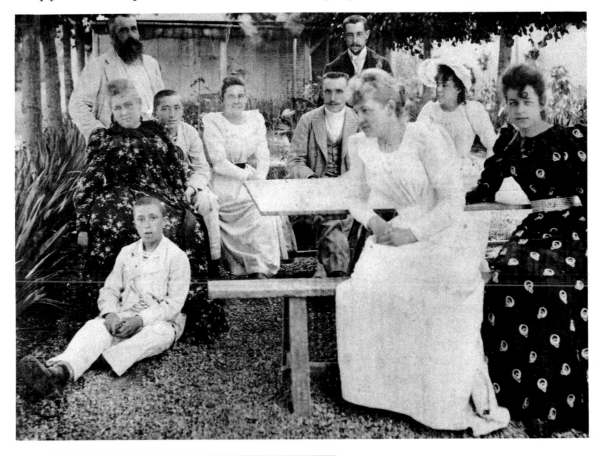

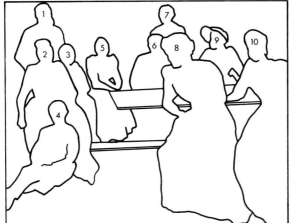

Some years after their arrival in Giverny, Monet surrounded by his family during an afternoon under the lime trees: 1) Claude Monet; 2) Mme Hoschedé; 3) Jean-Pierre Hoschedé; 4) Michel Monet; 5) Blanche Hoschedé; 6) Jean Monet; 7) Jacques Hoschedé; 8) Marthe Hoschedé; 9) Germaine Hoschedé; 10) Suzanne Hoschedé.

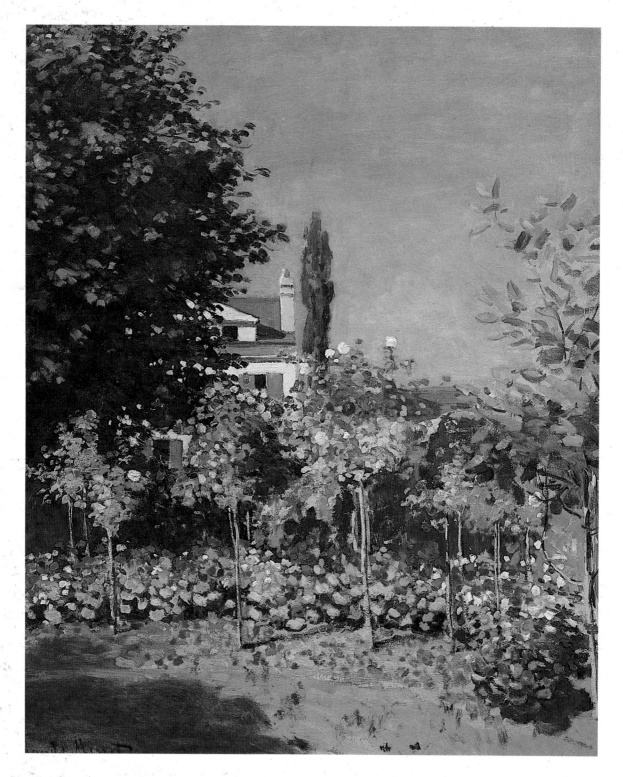

Jardin en Fleurs (Flowering Garden). 1886.
25⅜ x 21½″ (65 x 54cm).
Galerie du Jeu de Paume,
Musée d'Orsay, Paris.

opposite: *Camille dans le Jardin d'Argenteuil*
(Camille Monet in the Garden, Argenteuil), 1876.
32 x 19½″ (81 x 59cm).
Collection Mr. and Mrs. Walter H. Annenberg.

trek through the fields to Nettle Island, had damaged the crops. Monet felt obliged to pay, faced as he was with the threat of being denied access to his motifs on the Seine.

At Nettle Island some malicious individual spied on the family's pleasures and several times cut the moorings of the *norvégienne*, which drifted toward the lock several kilometers downstream. Thus Monet, who had difficulty providing for his family's daily existence, resolved to construct a boat house for his craft and to build a proper pontoon for mooring the boat-studio which he desperately needed for his work.

Then, hardly had he begun painting haystacks when the wily peasants suddenly made haste to demolish them. And when he undertook his series of poplars, they announced with ill-concealed glee that the trees were to be cut down. The artist gained a stay of execution by buying off the self-appointed executioners. But once settled into the calm of Giverny and eager to paint, Monet decided to treat such insidious malevolence with contempt and learned to ignore his neighbors. For him, thenceforth, life ceased at the gates to his property.

below:
In its denuded, wintry state, the
garden reveals the geometric
structure of its flowerbeds, a structure
that would all but disappear under
the lush, tiered growth of summer,
even though contained by mixed
borders.

opposite: Monet in the 1890s,
as photographed by the American painter
Theodore Robinson.

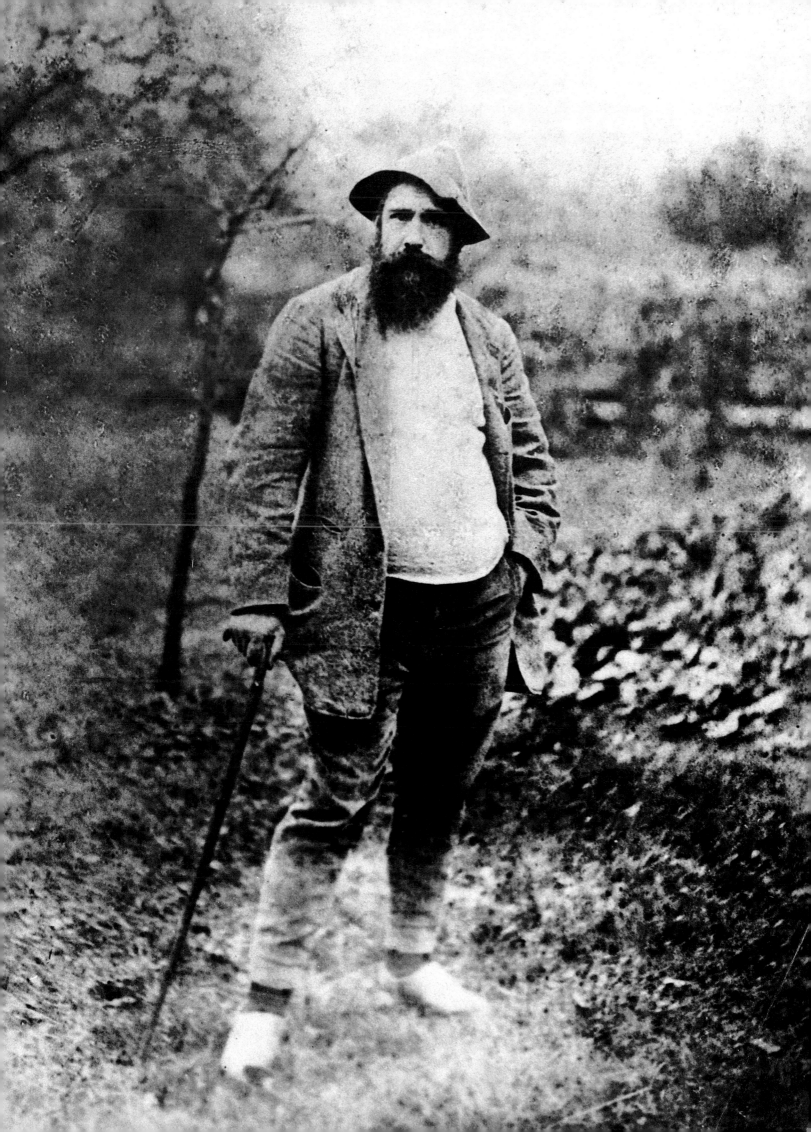

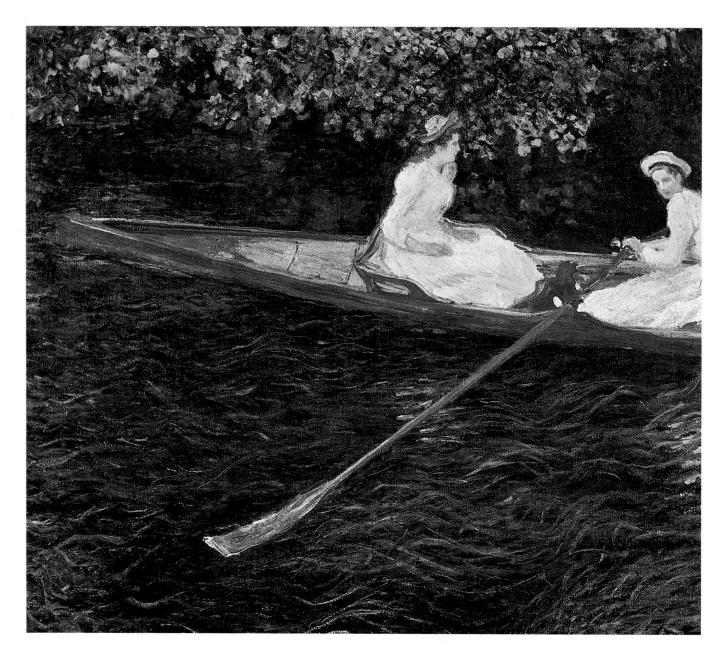

En Canot sur l'Epte (Boating on the Epte).
1890. 4'4¼" x 4'9" (133 x 145cm).
Museu de Arte, São Paulo, Brazil.

opposite above: *Le Printemps* (Spring). 1886.
25½ x 31¾" (65 x 81cm). Fitzwilliam Museum,
Cambridge, England.

opposite below: *Dans le Marais de Giverny,*
Suzanne Lisant et Blanche Peignant (In the Woods at Giverny:
Blanche Hoschedé-Monet at Her Easel with Suzanne Hoschedé Reading).
1885–90. 36 x 38½" (91.5 x 98cm). Los Angeles County Museum of Art
(Mr. and Mrs. George Gard De Sylva Collection).

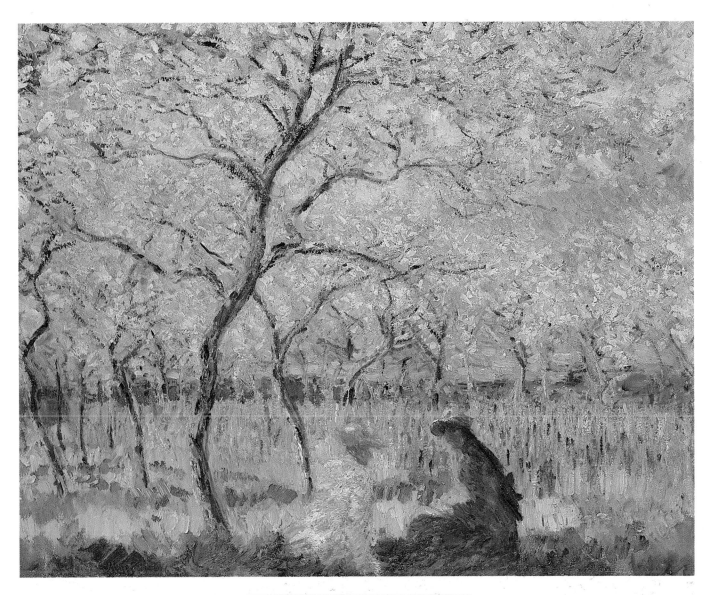

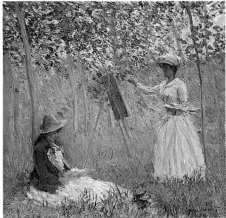

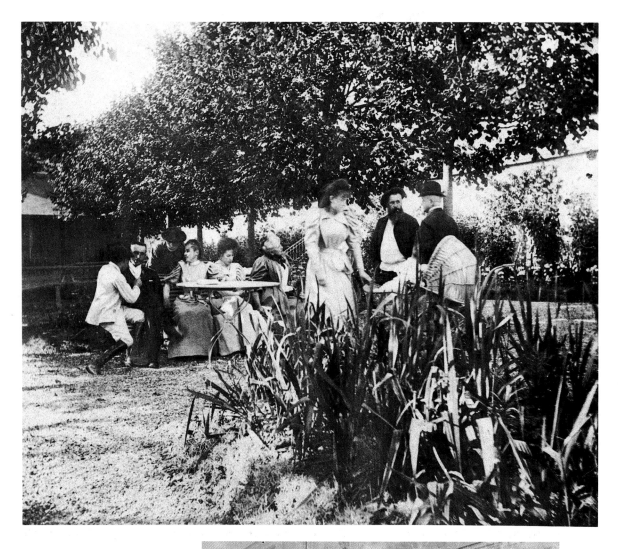

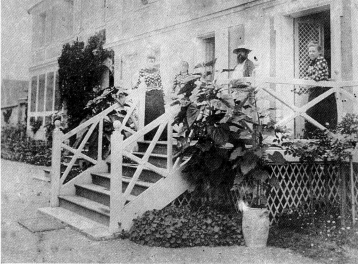

Under the lime trees in 1893, during a visit from Paul Durand-Ruel, the Impressionists' patron-dealer and a great friend of the Monet family. Durand-Ruel is the man in the bowler hat talking with Monet and Suzanne Hoschedé Butler. At the extreme right in the group seated at table is Alice.

right: On the "balcony" where lunch was taken in fine weather, Monet and three of his stepdaughters: Suzanne, Germaine, and Blanche. The girls often dressed alike in those days.

Paul Durand-Ruel and Monet

Throughout this time the sole source of material support available to Monet was Paul Durand-Ruel, "Monsieur Durand," who sold pictures because he had a gallery but bought paintings because he liked art. This good angel risked his fortune, while also jeopardizing his reputation, in order to discover new talent. And by staking Monet and his friends to their exhibition in Nadar's studio, he pushed himself to the very brink of disaster, where he would in fact remain for some time. Even his family began to wonder whether he had taken leave of his senses, for as a result of his "folly" in backing the so-called "Impressionists," the good man had become the laughingstock of Paris. All the while that official, academic, or "Salon" art continued along its serenely triumphant way, Durand-Ruel went on stubbornly acquiring hundreds of *croutes* ("crusts" or "daubs") by those pretentious buffoons who prided themselves on painting "impressions."

Monet, like his fellow experimentalists, received money on demand as advances against the delivery of paintings that had hardly been sketched in, and he used it immediately to defray such costs as Jean's school fees. Moreover, he had his paint supplier and even his tailor send their bills to the Durand-Ruel establishment in the Rue Laffitte. With Durand-Ruel, a man of unassailable integrity, agreements were always flexible, and no one hesitated to trust his accounting procedures, however acrobatic or inextricably complicated these may have been. Even though the beneficiary of advances, Monet never released pictures to his dealer until he felt completely satisfied with them. But often, just as he was about to fasten down the crates for dispatch to Durand-Ruel, the painter detected some inadequacy and began retouching until he had ruined the work. Sometimes he even ended up scraping, slashing, and finally burning his pictures, believing, correctly enough, that after him no one would do it. Such autos-da-fé horrified the family, but purged by his masochistic behavior, Monet could then resume work.

Mirbeau warned Monet to guard against his obsessive perfectionism, and Geffroy implored him to stop scraping his landscapes and figures away. Later Clemenceau would write the artist during his work on the so-called *Large Decorations*: "They will be supreme masterpieces provided you have not already spoiled them. . . . "

Monet was also constantly behind schedule, but who, really, could complain? It was important for Durand-Ruel as much as for the artist to offer a reticent public only his best work. The patient dealer nevertheless continued sending money, until finally, as he himself approached ruin, in the aftermath of his banker's own failure, he had no choice but to withdraw, momentarily, his support from the Impressionists. As a consequence of this crisis, however, Durand-Ruel entered upon his great American venture, the repercussions from which no one could then have imagined.

Actually, Monet understood his desperate situation well enough. He would, of course, go on destroying pictures for the rest of his life, but for the moment he braced himself to sell cheaply and even solicit buyers in order to survive. Never, though, would he consent to give his pictures a more "finished" look—what the French call a *léché* or "licked" quality—merely to please the crowd. Meanwhile, the bad old days of humiliating necessity had returned.

The allowance made to Alice Hoschedé by her family and the bit of income Monet received from Durand-Ruel, supplemented by the occasional sale to a private collector, enabled the artist to work in relative tranquillity, but never did it suffice, any more than it had at Argenteuil, to underwrite his simple but substantial lifestyle.

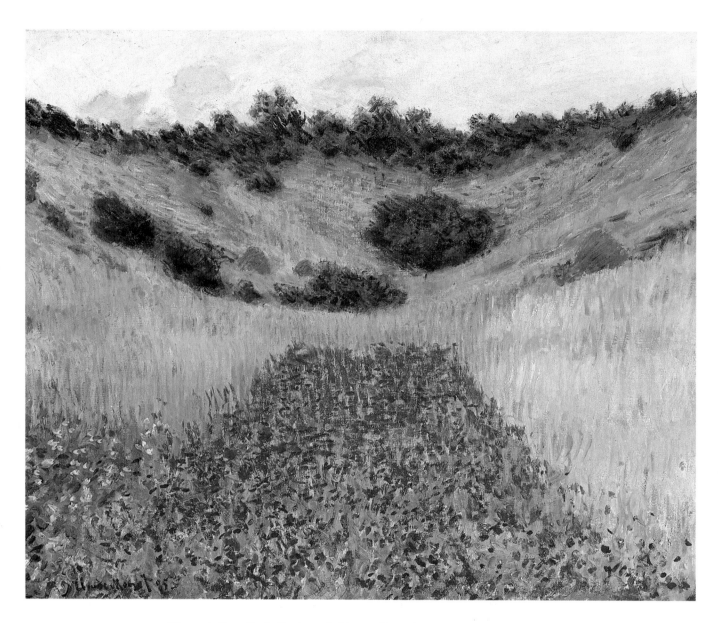

Champ de Coquelicots, Environs de Giverny (Poppy Field in a Hollow near Giverny).
1885. 25⅝ x 32″ (65 x 81cm).
Museum of Fine Arts (Juliana Cheney Edwards Collection;
bequest of Robert J. Edwards in memory of his mother), Boston.

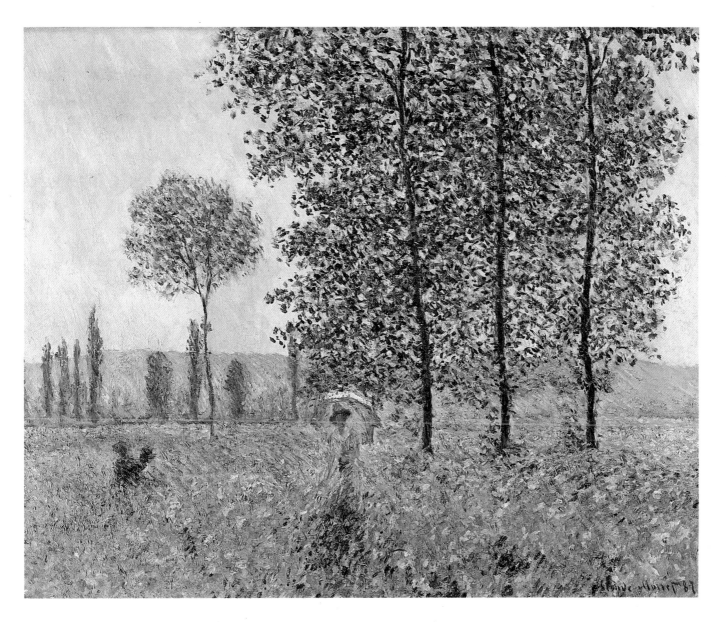

Sous les Peupliers, Effet de Soleil
(Under the Poplars, Sun Effect). 1887.
29 x 36″ (74.3 x 93cm).
Gemäldegalerie, Stuttgart.

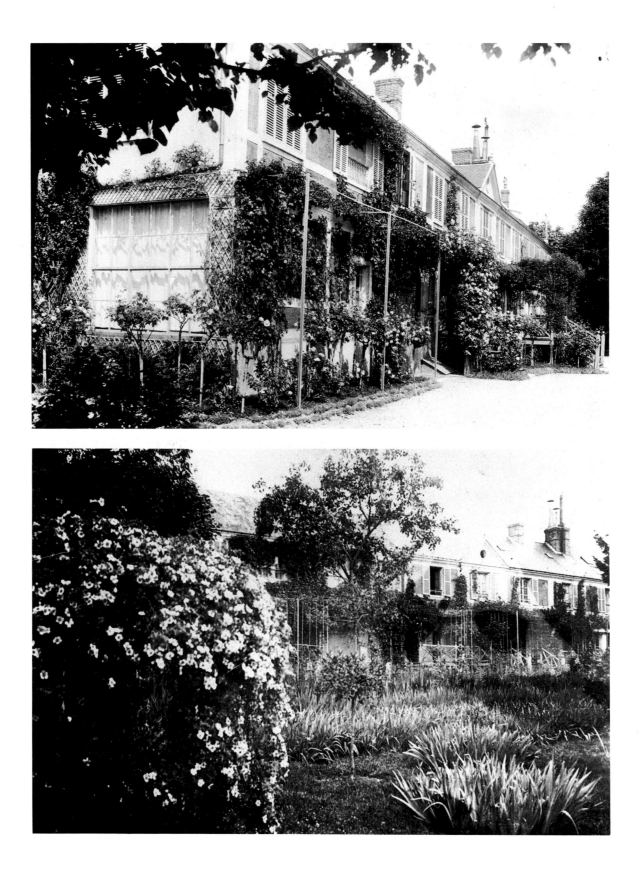

At Giverny the art of the *potager*, or "kitchen gardener," subtly practiced as the seasons turned and bred by the unforgettable dining standards set at Le Havre (Monet's parental home) and Rottembourg, reflected the needs of a cultivated palate more than those of careful economy. Even when, in July 1884, a disheartened Monet could write to Durand-Ruel that "I'm convinced that once again destitution will be our lot, despite all your admirable efforts," a visit to the kitchen would have found two servants hard at work. Furthermore, a tour of the dining room would have discovered wine bought on credit glowing red in the crystal carafes, the aroma of roasted meats floating in from the kitchen, and Condés of apples in gooseberry glaze enthroned on the sideboard. And Alice never stopped having Parisian tailors make her dresses and cloaks—from surah and cashmere, no less—and Monet his suits, at the same time that the whole family felt it essential that they go for the season at such fashionable watering places as Forges-les-Eaux and Salies-de-Béarn.

Still, in a household often up-ended by whimsy, the daily regimen was one of near monastic strictness, with everything about it designed to serve the needs of painting. Always up at four or five in the morning, depending on the season, Monet would open his window, on which the curtains were never drawn, and study the sky. Then, regardless of the temperature, he took a cold bath. Monet insisted that he loved getting up and that he often felt like returning to bed just for the pleasure of leaving it again. And the painter actually did go back to bed whenever the previous day's work failed to satisfy him or whenever the weather looked threatening. On those occasions he retreated under the blankets in anger and stayed in his room all day, refusing to come down to meals and rejecting all of Alice's attempts to console him. This situation might go on for days. Monet was of a difficult character, irascible and moody, forever dissatisfied with his work, liable to fly into a temper over a broken flower, an unexpected visitor, some inexpertise in the kitchen, and, above all, by the variations in weather and light. When Monet was in such tempers nobody dared speak a word or make a noise. And the tension would be broken only when the master reappeared radiant and full of fresh zeal for painting.

The landscape at Giverny fascinated Monet. He spent a long while exploring, walking over hills and through valleys, in marshes and meadows, among streams and poplars. Or, drifting down the quiet river in his boat, he would watch with a hunter's concentration for the precise moment when the light shimmered on grass, on silver willow leaves, on the surface of the water. Suddenly or by degrees his motif would be revealed to him. Monet's main stimulus was the close study of nature, of

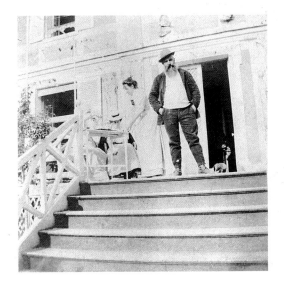

Tea on the balcony.

opposite above: In high summer, the house trellised and overgrown with Virginia creeper, clematis, and simple roses, which in time would be allowed to tapestry the entire façade.

opposite below: A cascade of clematis and clumps of iris spotted about on the lawn, in keeping with one of Monet's most cherished principles of gardening.

streams and quivering hedges, hills and green fields, the impalpable lilac haze that hangs above the Seine at dawn, figures dissolving in a diaphanous atmosphere, the glow of sunset over the bogs or the frozen stillness of a Normandy winter. When the artist began working in earnest at Giverny, the whole household revolved round his timetable and contrived to fit in with the rhythm of his work. The first improvements to the house had been made in the studio, so that a huge window now flooded it with light. The former barn also got an interior staircase, a new door, and pitchpine boards to replace the old floor of beaten earth.

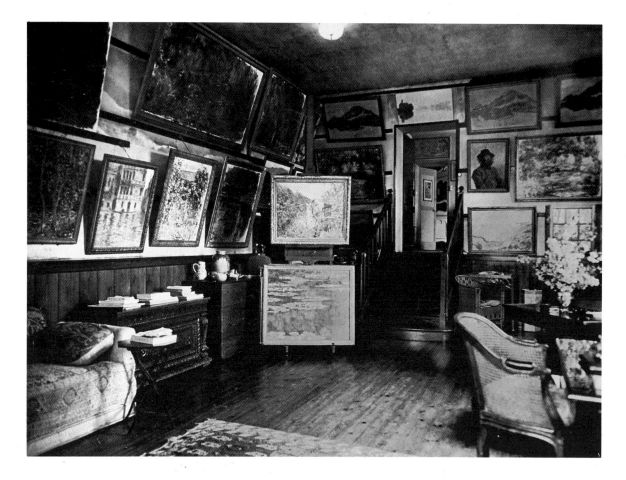

The prospect of prolonged work in the open air and several tastes acquired in the course of his travels abroad had given Monet regular breakfast habits that were quite rare for a Frenchman. In England, for instance, he had learned to like the best teas from Kardomah, while in Holland he had begun to eat cold cuts and cheese, even to drink milk on occasion. To all this he added eggs, grilled sausage, and toast with marmalade. Breakfast was an important ceremony and could be a delightful one, if Monet was in a good mood. Then he would invite one of the children to share it, and to go along with him to help carry his equipment. Blanche, who loved painting, was his most assiduous assistant. She often accompanied him to work, and Monet and his companion would load their gear onto a wheelbarrow and make their way through the dewy countryside to their hut on Nettle Island, to watch the sun rise. Or else they would get themselves driven in a horse-drawn cart to some more remote spot. Monet, who hated the very idea of painting lessons, would give her advice. They seldom chose the same subject, but their easels were never very far apart.

Monet always returned home at eleven sharp for lunch, which was served promptly at either noon or 11:30 after the bell had been rung twice. With a whistle he summoned Michel and Jean-Pierre, would tolerate no tardiness, and began to cough nervously if kept waiting.

After lunch Monet indulged himself in a brief respite, taking his coffee in the studio-salon, followed by a glass of homemade plum brandy. If the light had not changed too drastically, he went back to continue painting out of doors. Otherwise, he remained in the studio by himself working on his sketches, until interrupted at seven by two rings of the dinner bell. Invariably he went to bed by 9:30, so as to be ready to go before dawn the next morning.

During the holidays the rhythm could be more relaxed, with the whole family joining Monet on his painting expeditions. At Nettle Island he worked and sometimes played with the children, while Alice sat calmly sewing. At such times art shared the day with picnicking, boating, and tennis

After several trips to Etretat, a sojourn in Holland, and still another in the Creuse, Monet decided in the 1890s to stay at home and complete the series of *Haystacks* and *Poplars* on which he had been working so long. Little more than two steps from his front gate, the artist could see how the reapers' haystacks seemed, by turns, flattened like cardboard in the intense, vibrating luminosity of midday, blurred and dissolved in the morning or in a thick autumn fog, or yet heavy and solid, somewhat like tesserae in a mosaic, when snow had blanketed the fields.

Taking care always to plant his easel in exactly the same spot, Monet worked one canvas after another in rotating order. He could never know just how long the individual light effect would last, but he struggled to capture every one of them, not only at different hours of the day but also at different seasons. The same shifting conditions committed him to an equally epic undertaking for the *Poplars*, which he painted from his boat moored in the water. After so much effort, however, Monet had produced enough work for two successive exhibitions in which, as usual, he wanted to show "a good variety" of things.

Meanwhile, the indefatigable Durand-Ruel, on the lookout for a more receptive climate in which to present his artists, had organized two exhibitions in the United States, the first of which opened on April 10, 1886, with 310 works, including 50 by Monet. But while puzzled by the new art, the Americans had not laughed; instead, they made an effort to understand. Some critics even reproached Durand-Ruel, already known in America as a dealer in Realist and Romantic paintings, for having kept the French Impressionists "hidden" from them. This was a long way from the orgy of sarcasm staged at Nadar's or the grotesque demonstrations that had broken out at the Hôtel Drouot,

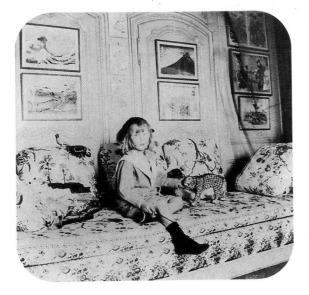

In the library also known as the "mauve salon," where Monet hung Hokusai's *Great Wave* and *Mount Fuji*. The little American boy on the sofa, James Butler, was raised in the home of his Monet grandparents.

opposite: In his first studio-salon, Monet kept pictures representing every period of his work.

when the police had to restore order. Truly, the United States represented the future

In May 1887 Durand-Ruel inaugurated the second of his first pair of Impressionist exhibitions in New York. A great *succès d'estime*, it encouraged the dealer to establish a regular branch of his business on New York's Fifth Avenue. Favorable as all this would seem, however, it enraged Monet, who wanted his reputation made at home; furthermore, he disliked the idea of his works leaving France permanently. This simply added to the chill in a relationship that had already begun to cool when Monet exhibited works with Georges Petit, a Durand-Ruel rival, in the third and fourth Expositions Internationales of 1884 and 1885. The rift between the painter and his faithful old backer widened in 1889 when Monet gave Theo van Gogh, Vincent's brother, ten of his Antibes landscapes for exhibition at Boussod and Valadon. Then in 1889 came the famous joint exhibition with Auguste Rodin, mounted by Georges Petit in his fashionable gallery in the Rue de Sèze. The catalogue listed 145 works by Monet and contained a preface by Octave Mirbeau. To Monet's disgust, Durand-Ruel refused to lend works from his collection, but even so the affair enjoyed a great popular success and brought the participating artists the semiofficial recognition they had long merited.

While critics and public alike may have found it easy enough to attack the supposed "folly" of Durand-Ruel, with his rather démodé gallery, only rarely would even the toughest observers dare to incinerate an exhibition sponsored by Georges Petit. And so they now exclaimed at the "surprising" progress that this Monet had suddenly made, even though the 1889 show was, in fact, a retrospective of work done since 1864.

So resounding was the triumph of the Petit affair that it even overflowed onto Durand-Ruel, who, after all, owned a considerable number of Monets. It also revived the friendship between Monet and his original dealer, but not until after several quarrels and a number of severe recriminations from both sides. And thus it was, properly enough, with "Monsieur Durand," who had borne all the risks for such a long time, that Monet would show his *Haystacks* and *Poplars* in two successive exhibitions in 1891 and 1892. All were sold within three days for prices between 3,000 and 4,000 francs. At the age of 51, Monet could now command the highest prices of all the Impressionists. From this time on he developed a stronger business sense, and although most of his output went to Durand, he avoided a formal agreement and continued to sell to other dealers as it suited him.

When reports of the *Poplars'* successful opening reached him, Monet was already painting his series based on the Cathedral in Rouen. Almost immediately he received letters asking for the first of the Rouen paintings, which nobody had yet seen. Monet, who spent years working on each of his series, must have smiled inwardly at this reaction. Pissarro wrote: "What a lovely thing, those three arrangements of poplars in the evening light, how painterly and decorative!"

A Man at Peace

At Giverny, Monet sacrificed almost everything to the demands of his painting, and for recreation he turned to gardening. But painter and gardener alike were subject to the seductions of water, an ineradicable fascination with roots deep in a footloose adolescence spent in Le Havre, a city wide open to the sea.

If Monet was not painting or in the garden, where else could he be found but in a boat? Life on the water became both natural and habitual for the entire family. They even talked about a "houseboat," and their preparations always began early for the September regattas. When race day arrived, the boats set off in the midst of an indescribable tumult and much waving of handkerchiefs until the craft had disappeared behind a curtain of willows at a bend in the river. The Deconchy–Jean Monet team was the most redoubtable, and it reigned supreme right up to the estuary. Sometimes mail was even addressed: "To Monsieur Deconchy, to Monsieur Jean Monet, Kings of the Boatmen. Martot Lock on the Seine." Boating remains a serious matter along the river, essentially just as it was when Maupassant wrote such breathless accounts of it.

In 1893 Monet, Mirbeau, and Blanche spent a week on board the transatlantic liner *Normandie* during a violent storm. On a deck deserted by all but the bravest, Monet and Blanche, clad in oilskins and settled into securely fastened chairs, watched the roiling sea, sometimes getting drenched by high, powerful waves. They were on their way to Cherbourg to watch the arrival of the Russian Tsar escorted by part of the Imperial fleet. Much later, when the artist recalled the voyage, the tempest took primacy over the deafening thunder of the artillery salute, over the sirens, the spectacle of gold-braided uniforms, the thousands of waving flags, and all the pomp, however unforgettable, that had accompanied Alexander III.

One can visualize an enthusiastic Monet leaving a speedboat that had participated in the Paris-Channel race, nimbly mounting the gangway of the *Dame Blanche*, the yacht of a friend in shipping, or simply caught up in some comic family expedition, arriving at the locks on board the boat-studio or the *norvégienne* towed by a barge, itself towed by a steamer.

For Monet, Giverny meant most of all a garden, a stretch of water, a landscape to paint, a working tool of infinite versatility, and he gave it no rest. Quite deliberately he remained aloof from public affairs and village life. He did not vote and refused to sit on the municipal council. No one could be less engaged than Monet was, and to the end of his life he would do for Giverny only what he thought he should do: protect the village against itself and save its sites from destruction, despite all the proposals couched in innocent-sounding phrases about progress and civilization.

Monet could do nothing, however, to prevent the widening of the Seine's shipping channel, which resulted in the disappearance of the little islands with the beaches of fine sand, in addition to, more unfortunately, the sublime motifs captured in the series known as *Morning on the Seine*. Tugboats had replaced them. The artist had also to bend before power lines and poles of every sort, which have almost succeeded in disfiguring the whole of the French landscape. Even the beautiful meadow where Monet painted *La Promenade* could not be spared.

Then one day Monet learned that the commune planned to sell part of the marshes to a starch factory. To stave off this calamity, this artist offered to take charge of draining and sweetening the land (a process that had been under discussion since 1860), provided the sale were set aside. No Givernois could possibly have imagined an opposition so violent—the utter madness—that it would

Champ d'Iris Jaunes à Giverny (Field of Yellow Iris, Giverny).
1887. 17¾ x 39″ (45 x 100cm).
Musée Marmottan, Paris.

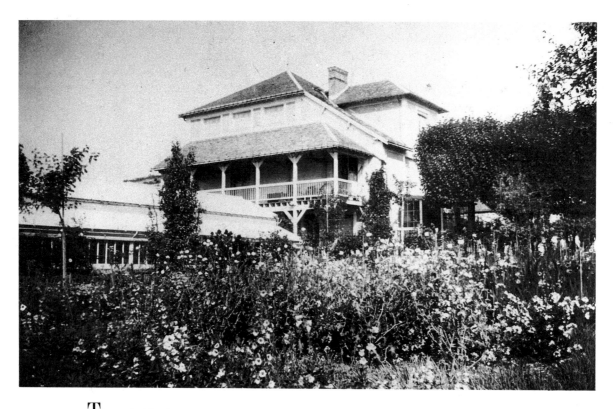

The orchid hothouse dominated by the studio built in 1897 and used thereafter by Monet.

prompt M. Monet to spend the colossal sum of 10,000 francs to preserve a miserable swamp: the natural slough where he painted so often, with its thousands of water iris and its poplars, the bog where everyone skated and held winter carnivals on ice.

After Monet had created his lily pond, automobile traffic became so heavy that it caused a thick layer of dust to settle on the aquatic blossoms. Made literally ill by this problem, the artist paid to have the road surfaced in tar the full length of his property, leaving the rest to the public authorities.

Finally, in 1903, Monet again opposed the municipality when it found nothing better to do than allow part of the commune to be totally transformed into a military zone. By then quite famous, Monet had, involuntarily, attracted to Giverny a good many foreigners and personalities of every sort. He promptly approached all these people, who signed a petition that saved the day.

Despite all these threats and his frequent painting trips to other parts of France and Europe, Monet, once settled in Giverny, never really thought of living anywhere else. Years went by without the possibility of a move ever presenting itself, until the autumn of 1890, when *père* Singeot, Monet's landlord and a man fully aware of how much the house meant to the painter, began urging his tenant to buy the property. Singeot, who drank *cailloutin*, the local wine, and was prey to a certain solid, peasant mentality, insisted on having 22,000 francs in exchange for a transfer of deed. Monet could now live quite comfortably; still, the price was a bit steep, and so he arranged to pay off the mortgage over a period of four years, thereby maintaining his own standard of living and that of *père* Singeot as well.

At last, Monet and his family no longer had to fear sudden assault by unpaid tradesmen. The pictures were selling (especially since the exhibition sponsored by Georges Petit in 1889), with the

48

revenue going for household improvements, a second studio erected near the lime trees, and the rare species that reappeared in the form of tropical plants and flowering trees, as well as for greenhouses and whole wagonloads of heath sod used to pot hortentias and rhododendrons. Increasingly, the garden became a subject to paint. Monet had always found motifs in bits and pieces of it, such as family luncheons under the tent, peonies in mulch, and bouquets of one variety of flower, usually monochrome. Now, however, it would be the garden's backbone—the *grande allée* or central walkway—that more and more claimed the artist's attention.

To have a beautiful garden to look at, Monet had to garden, but, more important, he had to garden so as to have a garden to paint, which meant that he never ceased working at his domain. Even when resting in his cane chair, the artist went on thinking about these two closely related realities.

Obsessive in his creative life, Monet cut himself off from the family except at mealtimes. Alice and her daughters could tell at once from the way he walked, or from the first words he uttered, whether his work had gone well. At meals they would discuss the trivia of daily life, the news from Jean in Switzerland, from Jacques in Norway, and from Germaine at her convent boarding school. Monet encouraged Jean-Pierre and Michel in their flower collection, which was, by now, of some scientific interest. During holidays he would organize trips for them to unfamiliar places where they could look for fresh specimens. The boys had, in fact, undertaken some curious cross-breeding experiments in the garden, with results that were sometimes splendid and sometimes disastrous. One day there appeared a very handsome poppy, a cross between an Oriental specimen and a common field variety. It spread abundantly in the flowerbeds. The boys, who were compiling a *Flora* of Vernon and la Roche-Guyon, consulted their advisor, the Abbé Anatole Toussaint, the local parish priest and a botanist of note, who decided that this cross-fertilization, although accidental, should bear the name *Papaver Moneti*.

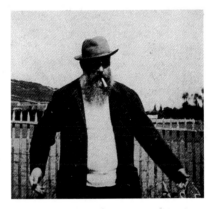

A few steps away from his own house, Monet in the garden of the Butlers on the Rue du Colombier.

Monet was a domestic tyrant, pernickety about the time for gathering beans, flying into a temper if some premature blossom had altered the subject of a painting. At the same time, however, he was as well known for his generosity and simplicity as for his mercurial temper. He was a loyal friend, reserved and yet warm-hearted, discreet and considerate, tender toward the unfortunate and indignant at injustice. Equally prone to absolute passivity and to extreme violence, Monet was driven to fury and roused to action by three lamentable events.

The first concerned Manet's *Olympia*, a painting the dead master was said to have regarded as his greatest work, an opinion with which his friends agreed. In 1889 there were rumors of its sale to an American collector. Monet, alarmed that the painting might leave France, decided to organize a private subscription to purchase the canvas for the Louvre, where he and John Singer Sargent believed it rightfully belonged. Throughout the year Monet tirelessly besieged his friends and acquaintances to contribute to the fund. The response was largely favorable, but there were surprising reactions from two of Manet's closest supporters. Émile Zola, who as far back as 1867 had praised Manet's talent, would not respond to the appeal. Antonin Proust, writing in *Le Figaro*, made it clear that he did not support the move either. Worse, he suggested that Monet and his associates were not motivated by interest in the painting itself, but in an oblique way were trying to help Mme Manet, supposedly in financial straits following the death of her husband. The "shocking and spiteful" article pained Monet, for Proust had been not only a Minister of Fine Arts but also a pallbearer at Manet's funeral. "He thinks it's natural," Monet wrote to Geffroy, "that Manet should not occupy the place he merits, whereas twenty fifth-rate daubers have all the glory." Nor did Monet mince words with Proust. Offended by them, Proust challenged the painter to a duel, which fortunately did not take place. Monet's seconds, Duret and Geffroy, prudently arranged a meeting between the two adversaries. Proust changed his mind, subscribed toward the purchase of the picture, and promised to apologize to Mme Manet. Finally, the subscription raised about 20,000 francs, from a list of contributors that included Degas, Duret, Lautrec, Mallarmé, Puvis de Chavannes, Renoir, Rodin, and Durand-Ruel. The painting went to the Luxembourg (then Paris's museum of modern art) in 1890, but it was not until 1907 that Clemenceau, then Prime Minister, could arrange for it to be transferred to the Louvre.

Coming on top of the *Olympia* affair, like a pendant to it, was the scandal of the Caillebotte bequest. At his death, Gustave Caillebotte had left his collection to the state, and the scorn heaped upon a man who had been courtesy personified was enough to leave his friends stupefied with horror. For instance: "There has been admitted to this museum [the Luxembourg], by what condescension I cannot imagine, a collection formed by a mediocre painter named Caillebotte, now deceased, who has given it on conditions that the Fine Arts Ministry has recently accepted. As a consequence, this sanctuary, meant for true artists, has suffered an invasion of work of an extremely questionable character, a character at the very antipodes of the perfection expected of art and the masterpieces that are its glorious issue." For their part, Monet and his friends preferred to leave the Senator responsible for this statement to the judgment of history and to hope for better, if not more civil, days, when the legacy of poor Caillebotte would finally dishonor the walls of the Luxembourg with four Manets, sixteen Monets, eight Renoirs, thirteen Pissarros, eight Degas, eight Sisleys, five Cézannes, and a single Caillebotte.

The third event to incur Monet's righteous indignation was the Dreyfus case, which contaminated French politics for many years, beginning in 1894. The whole country was at odds over the problem, which shattered families, friendships, and old associations. Even the Giverny household could not avoid becoming involved. In December 1894 a young Jewish officer, Captain Alfred Dreyfus, was tried and convicted of treason for selling military secrets to the Germans. The Dreyfus family and many others were convinced of the condemned man's innocence, and indeed Dreyfus had been

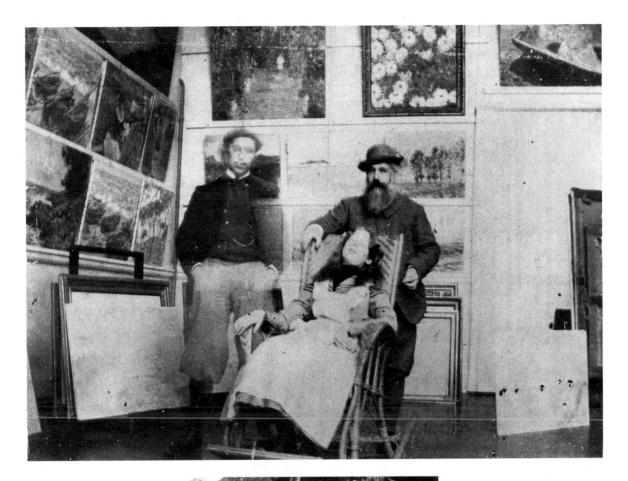

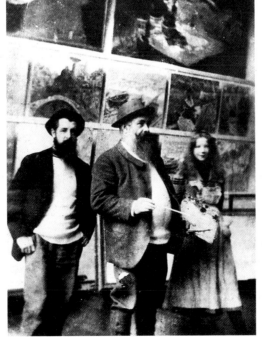

Monet in the second studio, where he painted, received collectors, and on occasion invited family and friends to view his most recent work.

above: Monet pushing the rocking chair occupied by Anna Bergman, next to Michel Monet, the painter's younger son.

left: In the same studio, Monet with Anna and Jacques Hoschedé, his stepson.

convicted on very slender evidence. When, in 1896, new evidence pointing to the guilt of another officer, Esterhazy, came to light, the Dreyfus supporters, including Monet's friends Clémenceau and Émile Zola, launched a massive campaign demanding a retrial. Monet, a convinced Dreyfusard, joined them. The accusations against Esterhazy resulted in a court-martial that acquitted him of treason in 1898. In protest against the verdict, Zola published, on January 13, 1898, his famous letter *J'accuse* in Clemenceau's newspaper *L'Aurore*. There the novelist attacked the army for illegality in covering up its mistaken conviction of Dreyfus. For his pains, Zola himself went on trial and was found guilty of libel, whereupon, at the urging of his friends, he fled to England.

The Monet-Zola relationship had been through its ups and downs. At the beginning, in the 1860s and 1870s, when Monet was virtually penniless, Zola, by no means rich himself, had helped the desperate artist on several occasions. Then, in 1886, came the publication of *L'Oeuvre*, the novel in which Zola presented his hero as an Impressionist painter whose dreams and ambitions end in failure and suicide because of his lack of talent. The novelist's own notes reveal that the portrait was based partly on Manet and partly on Cézanne, the two painters Zola knew intimately. Because Cézanne had been Zola's friend since childhood, he especially felt betrayed, but also humiliated by his sudden awareness that Zola actually pitied him. Not only had Zola misunderstood the aims of the Impressionists, but, worse, he had been disloyal. Cézanne wrote to thank his old friend for the copy of *L'Oeuvre* and said farewell, thus ending a thirty-year relationship. As for Monet, he too wrote Zola and did so in brutally frank terms:

My dear Zola
You've been good enough to send me L'Oeuvre. I'm most grateful to you. I've always derived great pleasure from reading your books, and this one held a double interest for me, since it touches on artistic matters over which we have long battled. I've just read it and remain, I must confess, troubled and disturbed. You've taken care, deliberately, that none of your characters resembles any of us, but even so I fear that our enemies in the press and public may think of Manet or even one of us as failures, which is not, I trust, your intention.

Forgive my saying this. I don't wish to be critical; I read L'Oeuvre with great pleasure, discovering memories on every page. Moreover, you know my fanatical admiration of your talent. Still, I've had a long struggle, and I'm afraid that just as we begin to arrive our enemies will use your book to deal us a fatal blow.

Please excuse this overly long letter, remember me to Mme Zola, and, again, my thanks.

Your devoted, *Claude Monet*

Despite all this, Monet now found *J'accuse* to be a brilliant and courageous manifesto, and thus rallied behind Zola, as did Pissarro. Degas, on the other hand, joined the militarists, turned anti-Semitic, and avoided his fellow Impressionists. Nor could Cézanne forgive the once-treacherous Zola.

The Invasion of Giverny

At quiet, sleepy Giverny, a village alive only to the timeless rhythms of sowing, haymaking, and harvesting, Monet burrowed in behind his walls of roses and nasturtiums, and thought himself sheltered from every outside disturbance. Little did he reckon with the storm that would suddenly break over the painting academies in Paris and, without warning, come whistling into the village of Giverny. The refugees from officialdom appeared out of nowhere—that is, from St. Louis, Providence, Washington, Philadelphia, Chicago, New York, and, most of all, Boston, by way of Paris. It all happened quite simply, and it took only a coincidence or two and a bit of gossip. Deconchy brought Theodore Robinson, a young American painter working near Fontainebleau, and presented him to Monet. Robinson wanted to see Giverny again, and so he returned.

A short while later, another American, Willard Metcalf from the Académie Julian, while walking in the neighborhood, stumbled upon Giverny in full apple-blossom time. Enchanted, he asked for a room at the grocery-bistro. The sight of this bearded giant babbling heaven knows what mix of languages so frightened Mme Baudy, the proprietress, that she slammed the door in his face. Not in the least put off, Metcalf returned a few weeks later with three friends, also from the Académie Julian. Seeing their easels, Mme Baudy now understood that her suppliants were artists and not dangerous highwaymen. She even rented them her own room and began cooking for the group. Finally they learned that Monet lived nearby, no more than a few steps from the auberge. After ringing at the painter's gate, they were, contrary to all precedent, received and quite courteously at that. A delighted Monet even invited the young men to stay for lunch. Thereafter these pioneers of the American invasion would often be welcomed in the Monet household. Meanwhile, they returned that very afternoon to paint inside with Blanche.

So far so good, but then they returned to Paris and talked rather too much. The legend of Monet filtered throughout the sacrosanct academies, with the secret of his retreat bruited about all of them. The rumor swelled as it traveled until everyone knew of the village with its auberge, fine cuisine, and absurdly low prices. Soon the rush was on.

In the Baudy establishment the artists' discovery of Giverny very quickly became a catastrophe. M. Baudy, being a traveling salesman of sewing machines, left the management of the "café" entirely to his wife, who suddenly found herself overwhelmed every weekend when the little train deposited hordes of shaggy, bearded, merry artists in search of a place to sleep and eat. After fitting out whatever rooms she could, the harried lady lodged the overflow with her neighbors.

Gradually, skylights began to sparkle in roofs everywhere, and before long a village of three hundred souls would boast more than forty studios. No lane was without its painter, sculptor, or indeed writer. There would even be an art school for American girls—*peintresses*—who would stop in Giverny on their way to an obligatory "tour" of Italy.

While Americans were its principal component, the invasion also included a Czech named Radimsky, who loved bicycling and ice-skating and who would marry his model, Louise, the village dandelion gatherer. Then came Thornley, a Norwegian, an Englishman named Watson, the Scotsman Dice, who occasionally wore his kilt and played a mean bagpipe, and a Japanese, a pointer for the American sculptor Frederick MacMonnies. A fair number of them, such as Hart, Beckwith, and Theodore Butler, had been brought by Robinson or Sargent.

The grocery-bistro had its first studio built in the garden, with two others soon installed on the

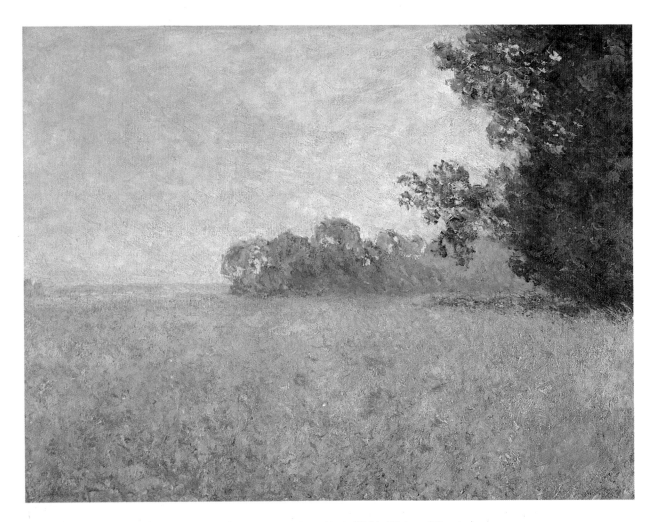

Le Champ d'Avoine aux Coquelicots (Field of Oats and Poppies).
1890. 25¼ x 36″ (65 x 92cm).
Musée des Beaux-Arts, Strasbourg.

opposite above: *Meules, Grand Soleil* (Haystacks in the Sun).
1890. 23 x 39″ (60 x 100cm).
Hill-Stead Museum, Farmington, Conn.

opposite below: *Meules, Fin de l'Été, Effet du Matin*
(Haystacks, End of Summer, Morning Effect). 1891.
24 x 39″ (60 x 100cm). Galerie du Jeu de Paume,
Musée d'Orsay, Paris.

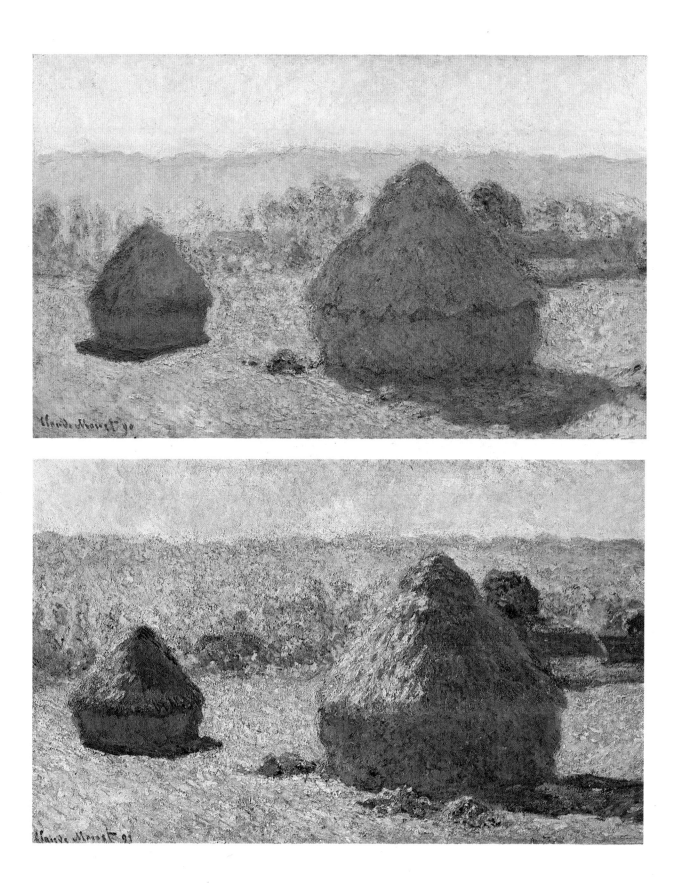

top floor of the house. Henceforth it was the Hôtel Baudy, where one could dance, drink deep, and carouse until all hours of the night. The walls of the dining room filled up with canvases, some of them gifts, others left as pledges against unpaid bills.

Dice, finding the tea undrinkable, taught Mme Baudy how to make a proper cup. The grocery, which remained in business, now stocked tea imported from England, along with puddings, maple syrup, marshmallows, and even paintbrushes, canvas, and frames, for Mme Baudy had been entrusted with representing Foinet, the famous Parisian supplier of artists' colors and other materials. Her kitchen, meanwhile, proved sufficiently adaptable to prepare Boston baked beans and the traditional Thanksgiving dinner.

If the studios filled up, so did the surrounding fields, with the large white umbrellas of the *plein-air* landscape painters. Models were recruited locally or, if budgets permitted, imported from Paris.

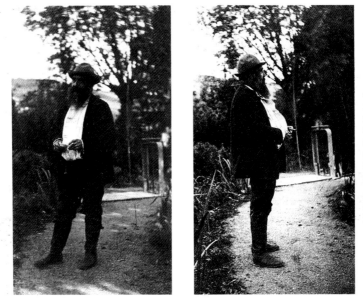

Several times every day Monet made a tour of his gardens. Even during these walks, the artist never ceased thinking about his painting, and the successive transformations he made in the pond were born of those painterly meditations.

opposite left: May 1907, a family automobile excursion to Sologne for a stay at the Hôtel Tatin and a taste of the famous tarte invented by the Tatin sisters.

opposite right: Monet posing for Lily Butler.

The daughters of the Perry family and the Hoschedé sisters had marvelously good fun in the company of Watson and his wife. Watson actually had the idea of matching the Parisian satiric review *French Letters* with satiric Givernois review, this one called *Innocent Letters*, published locally with the most rudimentary means but abundantly illustrated by the whole art colony.

The colony developed the most astonishing array of recreations. Metcalf collected birds' eggs, while accompanying Michel and Jean-Pierre on their botanical trips. There were hunting parties with Rose, reputedly the best shot in Giverny. One could go cycling with Radimsky or do photography with Robinson. Becktell and his sister, both painters, devoted many hours to constructing a sailboat, which would never go on water but remained under the trees of the Hôtel Baudy. Some of them even forgot that they were painters, while others never were. As for Stanton Young, painter and formidable tennis player, a partner of the King of Sweden during the monarch's stay in Cannes, he abandoned his brushes altogether in favor of building and managing a pair of tennis courts at the Hôtel Baudy. On the terrace, villagers mixed with artists, attended the matches, and kept score over a glass of their favorite libation. In the evening the Givernois could return for a concert played on bagpipes, piano, or banjo and dance late in the glow of lamplight.

The Americans who bought houses tended to entertain in a more sedate and exclusive atmosphere redolent of the American South. Elsewhere hospitality could be less formal. Young, for

instance, gave a memorable party for 150 Americans from both Paris and Giverny at the Moulin des Chenevières. And some of the American residents even kept open house. If invited there, however, it would be better, according to a French lady summering in Giverny, if one were polyglot: "To take part in Givernois society, it is essential to speak English."

For Monet, all this effervescence was disturbing, hectored as he was by requests for painting lessons, which he refused absolutely ever to give. This was the man, after all, who had yelled to his friends in the Gleyre studio: "Let's get out of here; the place is unhealthy!" At first hospitable to the new arrivals, he finally shut his doors to all but a select few: Robinson, Beckwith, Hart, and, later, Theodore Butler. He liked the Perrys, his American neighbors, happily chatted with Lila Cabot Perry, also a painter, and occasionally invited her into his studio. The first time she went there it was to buy a picture. Having chosen an *Étretat*, she found herself informed that the painting could not be taken

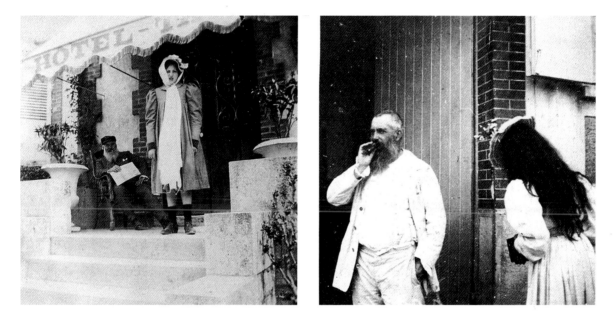

away, for the artist felt he had to retouch it, a process that would require his returning to the Channel coast. But what most struck Mrs. Perry that year, 1889, was the canvas on which Monet was then working, a rare portrait and in an uncharacteristically dark pallet. The subject was none other than Suzanne Hoschedé, wearing a mauve-violet dress and leaning on a small table set with a bouquet of sunflowers. The somber, even tragic tonality would seem prophetic to Mirbeau, inspiring him to compose some remarkable verses.

Mrs. Perry would also be witness one day to a distinctively Monet scene. In the home of her unpredictable neighbor everyone loved the large hothouse. A new heating system had been installed, and Monet, who never left anything to chance, decided to stand watch all night to make certain that the mechanism functioned properly, since even the slightest failure could cause irremediable damage to the orchids. Informed of his intention, Alice tried first to dissuade him from such folly, but, failing that, she determined to join him. Now the girls, in turn, became alarmed: "How's this, our parents alone the whole night in the hothouse. Unthinkable." And so the whole family jealously kept vigil over a coal heater that, in the end, performed most satisfactorily.

Despite his desire for privacy, Monet could not resist the pleasure of participating in the winter parties given on ice. Every day saw sleigh races and skating competitions, sometimes for the benefit of charitable works initiated by the invaders. The spectacle drew enormous crowds from the

surrounding district. Lanterns lit the path to the marsh illuminated with Japanese lanterns of every color hung in the trees.

On Christmas Eve, the decorated bog was abandoned earlier than usual, for the party had to end with Midnight Mass, only to be resumed after the service with *reveillons*, or "wakes," in friends' houses, where jugs of cider, almond cakes, and foie-gras toast awaited the skaters.

Christmas morning the village children called on the Monet household, then went on to the Johnston house, to the Butlers and the Youngs, and finally to the MacMonnies house, where a Christmas tree awaited them.

One day in November 1894 a horse carriage drew up in front of the hotel and deposited a curious figure wearing a cronstadt hat. It was Paul Cézanne. The reclusive Provençal artist had not seen Monet in a long while and wanted to paint at Giverny. The two men now saw one another regularly and exchanged canvases, all of which gave Cézanne encouragement and support, the two things in this world he most needed. Monet invited him often, but five minutes before lunch no one ever knew whether the temperamental Master of Aix would appear or not, since he could be easily frightened at the prospect of seeing new faces, convinced that any praise directed at his work was in fact an insidious form of mockery. Contrary to all expectations, Clemenceau did not intimidate Cézanne, who in fact took open delight in the wit and charm of the future Prime Minister's lapidary turns of phrase.

The pond following the first campaign to enlarge it, with Michel Monet and Anna Bergman standing on the recently built "Japanese" footbridge.

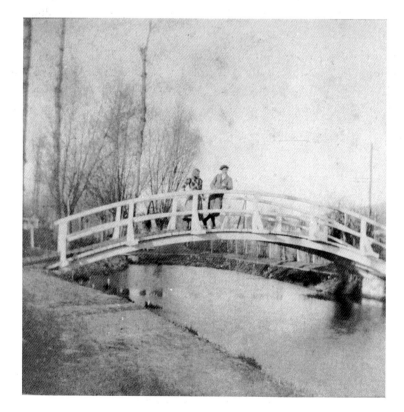

One lucky day when Cézanne felt particularly sociable, he met Gustave Geffroy at Monet's. Warming immediately to the critic, Cézanne wrote informing him that he would like to do his portrait, and signed the note: "Paul Cézanne, painter by inclination." Meanwhile, on the same day of the encounter with Geffroy, Monet also had as his guests Clemenceau, Mirbeau, and Rodin, the latter of whom became the occasion for some of Cézanne's most bizarre behavior. The sight of Rodin's Legion of Honor rosette so impressed Cézanne that he drew Mirbeau and Geffroy aside and made this astonishing remark: "M. Rodin isn't at all proud; he shook hands with me! A man who's been decorated!" After lunch, when everyone went for a stroll around the garden, Cézanne suddenly fell to his knees in front of Rodin and thanked him for shaking his hand.

At the Hôtel Baudy, Cézanne's presence did not go unnoticed, as we know from the witness of Mary Cassatt, the American Impressionist, who, as she wrote to her friend Mrs. Stillman, was somewhat disconcerted by the French artist's odd ways:

Monsieur Cézanne is from Provence and is like the man from the Midi whom Daudet describes: "When first I saw him I thought he looked like a cut-throat with large red eyeballs standing out from his head in a most ferocious manner, a rather fierce looking pointed beard, quite grey, and an excited way of talking that positively made the dishes rattle." I found later that I had misjudged his appearance, for far from being fierce and cut throat, he had the gentlest manner possible, *comme un enfant*, as he would say. His manners at first rather startled me. He scrapes his soup plate, then lifts it and pours the remaining drops in his spoon; he even takes his chop in his fingers and pulls the meat from the bone....Yet in spite of the total disregard of the dictionary of manners, he shows a politeness towards us which no other man here would have shown. He will not allow Louise to serve him before us in the usual order of succession at the table; he is even deferential to that stupid maid, and he pulls off the old tam-o-shanter, which he wears to protect his bald head, when he enters the room. Cézanne is one of the most liberal artists I have ever seen. He prefaces every remark with: *pour moi*, it is so and so, but he grants that everyone may be as honest and as true to nature from their convictions; he doesn't believe that everyone should see alike.

Then one day when at Monet's with Renoir and Sisley, who had been invited to Giverny in honor of Cézanne, the two visiting Impressionists seized on the occasion to praise their difficult colleague's art. An overcome Cézanne abruptly got up and left the table, his eyes filled with tears. After having no sign of him for several days, Monet went to ask for Cézanne at the Hôtel Baudy, only to learn that he had departed, leaving all his canvases at the auberge. This troubled Monet, for he realized that Cézanne must have thought Renoir and Sisley were making fun of him. Monet gathered up all the abandoned pictures and forwarded them to his strange guest, who subsequently sent a letter full of apologies but rather obscure in its explanations of the sudden desertion.

The next and last time that Monet saw Cézanne it was in the Rue d'Amsterdam. And it seemed as if Cézanne recognized Monet too, but he simply pressed on and disappeared. The old friends were never to meet again after the Giverny visit.

following page:
Monet entering his second studio.

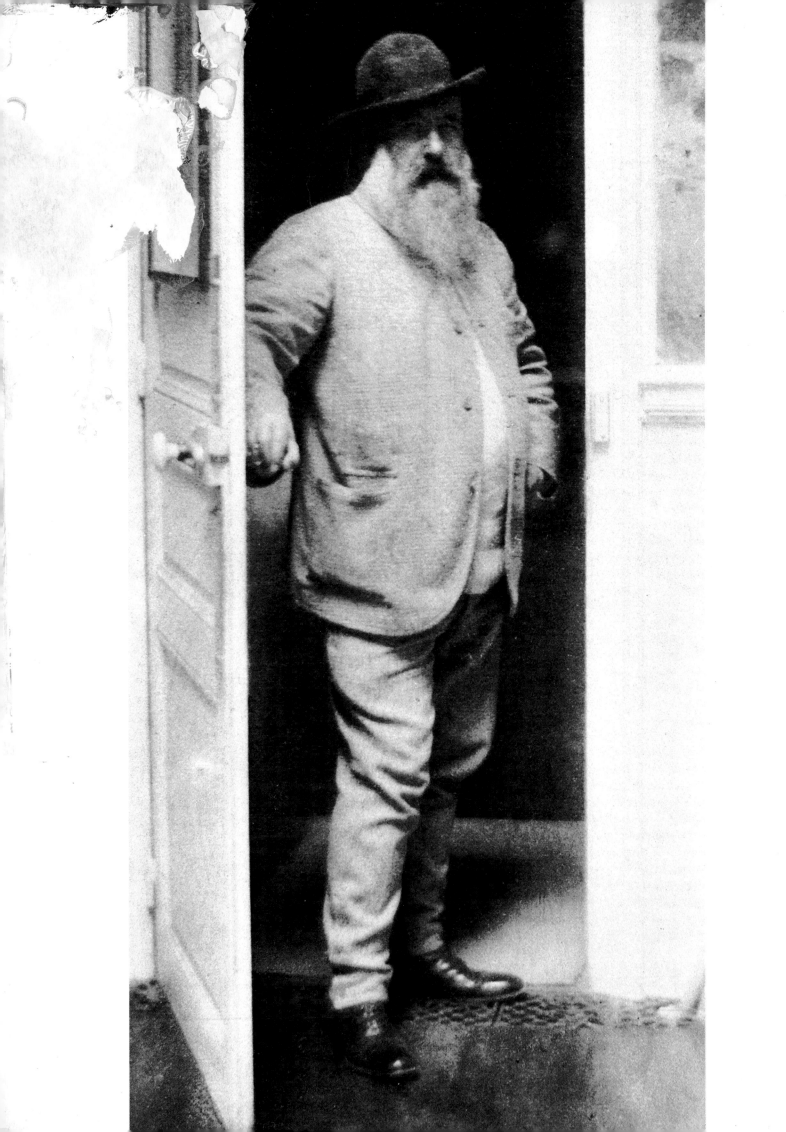

A Complex Family

When Monet and the Hoschedés settled at Giverny they put aside all memories of earlier backgrounds, and Giverny became their base. Home was now the unpretentious Maison du Pressoir, although only Michel and Jean-Pierre grew up there. Camille Monet and Ernest Hoschedé belonged to the past and were seldom mentioned, although they could be seen in paintings by Manet, Renoir, and Monet—all scenes at Argenteuil and Montgeron. What other images of Camille could Jean have retained? Michel, raised by Alice whom he called *Maman*, probably had none. And what vestigial effects could the Hoschedé children have felt from the infrequent meetings with their father, whose visits ceased one day?

Until his death in 1891, Hoschedé managed to maintain intermittent correspondence with his family, although a permanent reunion was impossible. He even visited the children from time to time, and they all exchanged regular birthday and Christmas greetings. When his health failed, Alice left Giverny and nursed her errant husband through his final days. Then she and Monet arranged for the funeral to be conducted by Abbé Toussaint in Giverny, with the entire clan gathered to pay their last respects.

Now Monet could rest secure in his position as head of the family, something he had not always felt free to do, as we know from a letter he wrote in November 1886 at the end of a painting campaign in Brittany: " . . . Finally, I'm coming and hope not to experience, as I sometimes do, that feeling of isolation and estrangement that has often troubled me. I return joyfully looking forward to seeing all of you, a feeling I trust you share. And so all should be well. . . . "

For a long time everyone, Alice included, had addressed the painter as Monet and used the familiar *tu*—everyone, that is, except Jean-Pierre and Michel, who for some strange reason felt embarrassed and always spoke to him in the third person, addressing him as *il* or *on*. They would say: *On va au marais?* meaning, "Father [or Monet], are you going to the marsh?" It was easier in letters, where they called him "Papa Monet," whereupon the recipient would sign his replies affectionately: "Your old Father," or "Your old Monet, who loves you as his child."

As for Mme Hoschedé, difficulties arose when the formal *Chère Madame* gave way to "My dear Alice." Actually, it had taken considerable courage on the part of the devout Alice Hoschedé to brave public opinion and become the companion of a man she could not marry—moreover a man who was not pious. For all their great mutual tolerance, their irregular relationship disturbed the couple in different ways. Lacking social sanction, it embarrassed Monet, who was traditionalist and conservative in such matters. Lacking God's formal blessing, it made Alice unhappy. Not only was divorce not part of their code, but it also smacked of sin, and the idea of it never occurred to Alice. Oddly enough, Monet, who smiled at Cézanne for dressing up to attend Sunday Mass, and who entertained Giverny's *curé* at table but went to church only for the most unavoidable ceremonies, hated violating the conventions of his time.

The Raingo family, Alice's relatives, approved of the arrangements at Giverny. They held Monet in great esteem and admired his work as an artist, and Alice's sisters, Cécile, Marie, Isabelle, and Marguerite, made frequent visits to the Maison du Pressoir. On the other hand, Monet had great difficulty with his brother, who for a long time, before they later quarreled irrevocably, would consent only to receive the painter alone or accompanied by his two sons, so great was his bourgeois concern about the opinions of provincial society.

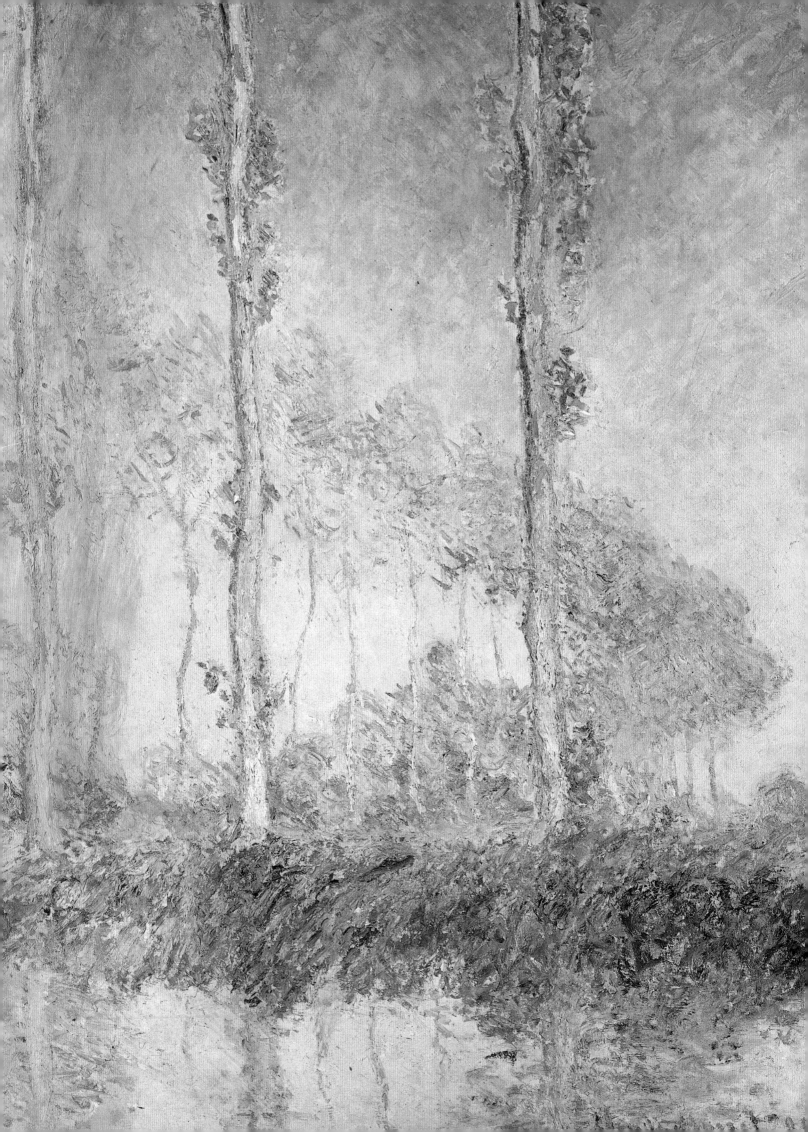

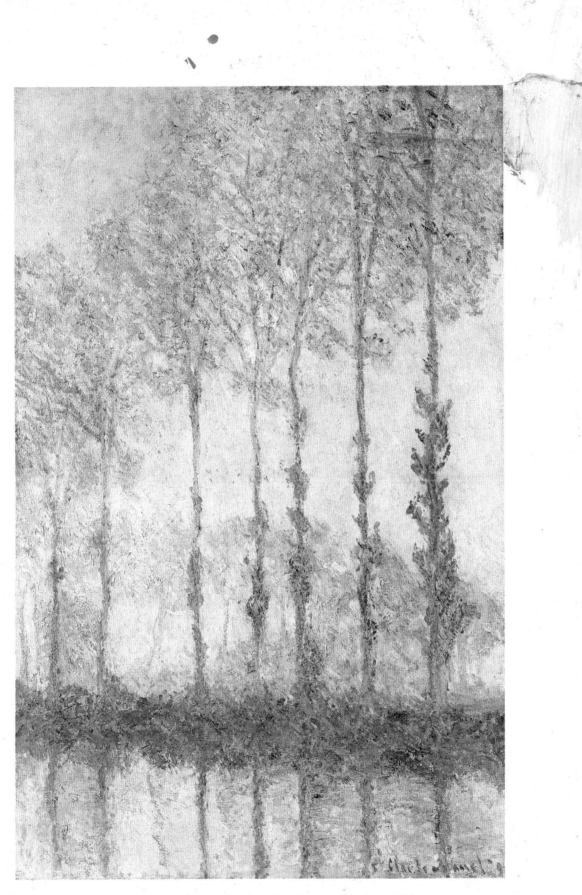

opposite: *Les Peupliers, Trois Arbres Rose, Automne* (Poplars). 1891.
36¼ x 29″ (92 x 73cm). Philadelphia Museum of Art (gift of Chester Dale).

above: *Les Peupliers, Effet Blanc et Jaune* (Poplars on the Bank of the Epte River). 1891.
39½ x 25¾″ (100 x 65cm). Philadelphia Museum of Art (bequest of Anne Thompson
as a memorial to her father, Frank Thomson and her mother, Mary Elizabeth Clarke Thomson).

Until their father's death, the Hoschedé children had never been pressured to consider careers, nor had they been required to shoulder any serious responsibilities. Now, however, Monet undertook to see to their futures, and this, from the young people's point of view, presented a somewhat disturbing prospect. Monet would certainly play the patriarch, making his word an indisputable law. There could be no question of a marriage without his approval, nor a career that he deemed unsuitable. In this regard, Monet—he who broke every rule in art—proved to be a typical *haut bourgeois* father when it came to his children and Alice's.

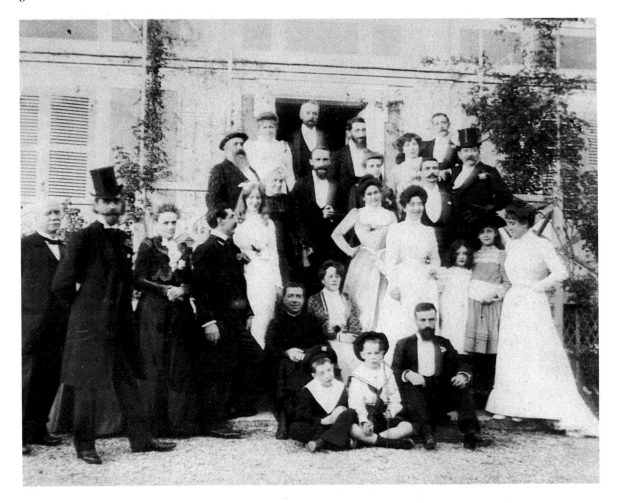

In 1900, Theodore Butler remarried, taking Marthe Hoschedé as his wife. 1) Paul Durand-Ruel; 2) Ernest Vialatte; 3) Isabelle Pagny; 4) Joseph Pagny; 5) Anna Bergman; 6) Mme Alice Claude Monet; 7) Jean Monet; 8) Claude Monet; 9) Marthe Hoschedé Butler; 10) Theodore Earl Butler; 11) Jean-Pierre Hoschedé; 12) Madeleine Pagny; 13) Blanche Hoschedé-Monet; 14) Jeanne Sisley; 15) Fernand Haunddorf; 16) Alice Raingo-Pelouse; 17) Lucien Raingo-Pelouse; 18) Achille Pagny; 19) Alice Butler; 20) Suzanne Raingo; 21) Germaine Hoschedé; 22) Pierre Sisley; 23) James Philippe Butler; 24) Germain Raingo-Pelouse; 25) Inga Jorgensoen-Hoschedé; 26) Abbé Toussaint, the curé of Giverny.

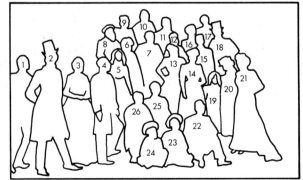

Jean Monet studied chemistry in Switzerland and went into practice with his uncle in Rouen. When he married Blanche Hoschedé in 1897 he became both stepson and son-in-law to Alice, and Blanche both stepdaughter and daughter-in-law to Monet. And as if to make it still more confusing for outsiders (since as far as the family were concerned, it was all quite straightforward), Monet often spoke of Blanche as "my daughter." Blanche, meanwhile, continued painting, but after Jean's premature death in 1914, she became the devoted companion and housekeeper to the twice-widowed Monet for the remainder of his long life.

Jacques Hoschedé, whom Monet had painted at Montgeron in *The Child with the Flowers*, acted on the family love of boats and became a shipbuilder in Norway, where Monet would visit him and where he married a Norwegian, Inga Jorgensoen, the widow of a Bergen lawyer and already the mother of a little girl, Anna Bergman.

Trouble developed when Germaine Hoschedé and Pierre Sisley wanted to marry. The Sisleys, Monets, and Hoschedés had exchanged visits throughout the children's lives, but now Pierre planned to be an inventor, an occupation Monet thought very insecure. Quite firmly, therefore, he forbade the alliance, and Germaine had little choice but to acquiesce in his decision. Broken-hearted and unhappy, she rallied to none of the concerts and dinners that Monet gave her in Paris. Finally, he sent the poor girl off, in the winter of 1901, to Saint-Jean-Cap-Ferrat to stay with the Deconchys. Urged to enjoy herself, she proceeded to do so once she met Albert Salerou, the Deconchys' friend and a lawyer from Monaco who collected both books and butterflies. As Pierre Sisley's image quickly faded, Germaine and Albert were married on November 12, 1902. At first they settled at Cagnes, near Renoir, but later moved to Paris, where Salerou entered politics and went to work for Clémenceau.

Jean-Pierre Hoschedé and Michel Monet, having finished their *Flora*, would also invent mar-

Michel Monet in the driver's seat of the motorized quadricycle he invented.

velous but irredeemably useless things. Completely absorbed in what Alice called their "tinkering" with bicycles, they would come out of the garage covered in grease and their clothes in tatters. Finally they produced a prototype vehicle, a petrol-fired bicycle built for two that caught on somewhat, if not outside Normandy or the Île-de-France. Jean-Pierre then studied agriculture in Périgord, where he stayed with a friend of Alice's and ended up marrying her daughter, Geneviève Costadeau, in 1903. To win the girl's affections, Jean-Pierre evidently undertook some rather daring exploits, most particularly in his high-speed descent of a steep hill, his feet on the handlebars of an extraordinary bicycle and howling to the surrounding countryside: "Darwin was right!"

Michel, although he cherished a lifelong passion for mechanics, had no career. Of all the children, he seemed the least capable of coping with his father's domination. Moody, reserved, and a "loner" par excellence, he refused to put his name to the *Flora* on which he had worked for so many years. Meanwhile, he painted in secret, no doubt overawed by his father's image. Only after Monet had died did Michel dare to marry Gabrielle Bonaventure, an artist's model of whom Monet greatly disapproved. Later, Michel and his wife took part in one of the first expeditions across the Sahara.

When it came to Suzanne, everybody was in a state of suspense. Theodore Butler, one of the merry invaders brought by Sargent, had asked for her hand. Neither Monet nor Alice wanted to see a child of theirs go off to America. Monet said as much to Butler, while Alice wrote to Mrs. Butler and also asked Beckwith to make an inquiry. After all, who was this friend of Sargent's, this proper Protestant who played the harmonium in church on Sunday morning and the banjo in the evening, and who, according to Durand-Ruel, set the fashion among the Americans in Paris.

All resistance crumbled, however, when it was learned that the Butlers had distinguished themselves during the Revolutionary War, when the Marquis de Lafayette was involved with the American struggle for independence, and that this family of prosperous bankers, who had never suffered financial ruin, would happily embrace a young, Catholic, and pretty Frenchwoman. Courtland, Theodore's brother, arrived in France to represent the family, but at a wedding whose date was forever being put off. Not only had the preparations turned the house upside down, but Courtland had business to conduct in London, and if the date had not been fixed by the time he returned, he would have to go back to the United States. In the normally well-ordered Monet household, something peculiar was going on. Mme Hoschedé seemed unusually nervous and preoccupied while Monet made cryptic remarks and Suzanne burst into tears. Finally, the dumbfounded Butler received a letter from his fiancée:

My dear Butler
I can well understand that you are saddened that the date for our wedding has not yet been set, but I assure you that *Maman* will join me in doing everything possible for my happiness and that this will soon occur. Only you cannot suspect that another, quite serious matter is to be settled quite soon, something that troubles *Maman* very much. You must not, therefore, mind if she is sometimes distracted and less friendly than is her wont. M. Monet intends to marry *Maman*, and in order to make things more regular, they both want it all to be done in time for our wedding, so that M. Monet may assume the responsibility he is eager to have and replace my father in escorting me to the altar, and also to be more at ease in his relationship with our family. It's a big secret that I'm entrusting to you, and you must promise to speak of it to no one.

The marriage of the "Woman with the Parasol" was finally celebrated in high euphoria, with all the huntsmen firing their guns in a traditional salute as the couple left the *mairie*. On July 20, 1892, Suzanne was led to the altar by Monet, and whereas the whole village, in addition to the American colony, gathered for the occasion, Alice Raingo-Hoschedé and Monet had been married four days earlier, on the 16th of July, 1892, in an exceptionally quiet ceremony, witnessed by Octave Mirbeau, Paul Durand-Ruel, and Paul Helleu, among others.

Domestic Rituals

In the house with walls built of brick-colored mortar, Alice spent her days performing a thousand small but indispensable rites. Making certain that the larder, called the "grocery," was well stocked at all times, she prepared menus a week in advance, took careful note of her guests' tastes, carried on a voluminous correspondence, and kept her diary.

In the kitchen reigned Rita, Caroline, and Mélanie, while Delphine had charge of the laundry and Breuil or Lebret the gardens. The garage was under the management of Fouillard and then Sylvain, who with equal ease handled the car's steering wheel, stretched Monet's canvases, bottled wine, or, for relaxation worthy of a descendant of Solognot hunters, played the hunting horn. To the great astonishment of the servants, no one ever referred to "Monsieur," only "Monet," as in "Sylvain, Monet is calling you," or "Mélanie, Monet has requested crêpes for dessert."

The Monet household made a virtual cult of good food, and ignorance of how to eat well struck the Maison du Pressoir as nothing less than a sure sign of barbarism. Although certainly a good trencherman, Monet was also a true gourmet with several obsessions. Never mind who may have been his guests, the artist insisted on carving at table all game, fowl, and roasts and even on seasoning the salads, which he literally turned black with pepper. Monet insisted that his foie gras come from Alsace, preferred the truffles of Périgord, and loved red beans cooked in the wine of Chanturgue. Addicted to fish, he would pay anything for pike even if caught in the pond by the gardener.

Monet drank only wine but, by his own admission, never became a connoisseur of good wine. He liked Sancerre, as well as the light bouquet of other small wines from the Loire Valley, such as a fragrant dry rosé. Another favorite was a full-bodied, flavorful red from a vineyard in the Massif Central. Champagne meant nothing to him, and at his table it was served decanted like some ordinary nonsparkling wine.

For the benefit of his table, Monet bought the "Blue House" in the Rue du Chêne and its walled grounds, as large as the Pressoir garden. There he would grow herbs, vegetables, spices, and other kitchen plants from the Midi, all of which Monet adored. The resident gardener also kept forcing frames and cultivated mushrooms in the cellar. The new property generated a steady stream of traffic to and fro between the "Pink House" and the "Blue House."

After several cooks departed as anonymous as when they arrived, leaving no memorable dish behind, Marguerite succeeded the difficult reign of Mélanie, whose tongue had been as wicked as her palate was superb. Beginning as a very young scullery maid, Marguerite became Mélanie's pupil and then a cook in her own right, adding an unequaled touch to the subtle skills of her tutor. So desperate was Monet to keep Marguerite at her post that when she married he hired her husband Paul as butler. Thus Marguerite continued to preside over her battery of saucepans, fish kettles, molds, and various ovens in the kitchen tiled in blue faïence.

With menus given to her a day in advance, Marguerite was able to order from the gardener at Blue House the necessary vegetables and have them gathered fresh at dawn or to buy others through the window from an itinerant kitchen gardener.

Marguerite could do anything, endowing a simple purée or a classic hollandaise sauce with an element of sublime mystery. She executed American recipes for Butler just as easily as a menu devised for a distinguished guest or a *crème somptueuse* for Clemenceau, who had surprisingly simple tastes. However, she did relatively little for tea. The precious caddy remained ensconced in the

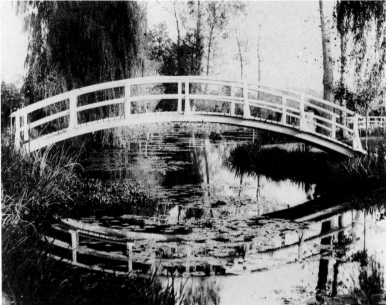

By giving the shape of his pond a more pronounced curvature, and by a subtle massing of grasses and clumping of trees, Monet succeeded in creating, within a restricted space, the impression of a vast perspective. Even after enlargement, the water garden lay entirely within little more than two acres.

salon-studio, where Paul carried boiling water, cheese sticks, and Marguerite's meringues. Both Marguerite and Paul had a rare gift in their aristocratic way with vegetables. Marguerite prepared positively unctuous spinach, finely chopped and cooked in a mere drop of water in order to preserve both the vegetable's flavor and its fresh-almond color. And every time Monet tasted the tender *flageolets* made by Paul he said: "My, he does them well!"

When asked about the secret of her culinary success, Marguerite would reply: "You add water, some salt...." "How much?" "Oh, not much; you can tell when the dough is no longer thirsty." This was about all she could ever offer by way of explaining her magic touch. Pressed further, she would simply shrug her shoulders and go on with her tasks, among the rows of glistening copper pans. The work all done, she would lose herself in reading *Pot-au-Feu* or a notebook of house recipes and make corrections: "Cook with tarragon! Pippin apples for fritters!" or "*Oeufs à la neige*! Is that what you call a dessert!" No one dared challenge her.

Life in the Maison du Pressoir was thought to have been divided between the pre-Marguerite era and the post-Marguerite age, and when this empress of the kitchen hung up her apron for the last time, on the eve of the Great War, things were never the same again at Monet's table.

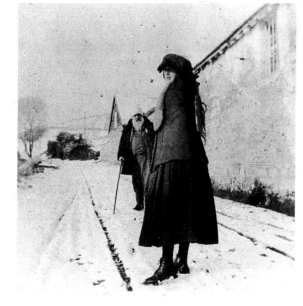

During the winter of 1910 the Seine overflowed its banks and caused terrible flooding throughout the valley. The gardens at Giverny suffered exten-sive damage. Monet and Lily Butler, the painter's American granddaughter by marriage, take a walk through the village, both alarmed and delighted by what they see.

Près de Vernon, Île aux Orties (Île aux Orties, near Vernon).
1897. 28⅞ x 36½″ (73 x 92cm).
Metropolitan Museum of Art (gift of Mr. and Mrs. Charles S. McVeigh),
New York.

Bras de Seine près de Giverny (Branch of the Seine near Giverny II).
1897. 34¼ x 38½″ (81 x 92cm).
Museum of Fine Arts (gift of Mrs. Walter Scott Fritz),
Boston.

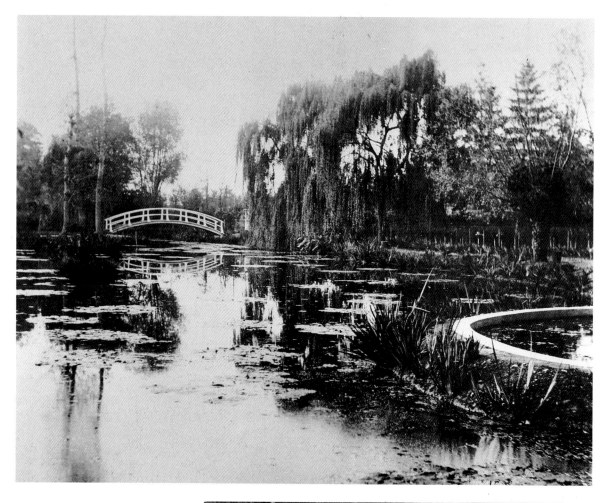

Monet conceived the idea of building a cement pool within the large natural pond and there cultivating some of the more fragile varieties of waterlily. However, he soon had to abandon the project owing to the unsuitable northern climate.

right: A photographic detail that Monet would use for the waterlily pictures he painted in 1900–10.

The "937-YZ"

Along with his successful career, the product of unremitting labor, and his comfortable life, made possible by fiscal vigilance, Monet would have to suffer a number of devastating blows struck not only among his friends but also at the very heart of his family.

Now playing in the garden was a new generation of children: Anna, the stepdaughter of Jacques; Jim and Lily, Suzanne's children; Sisi and Nitou, who belonged to Germaine; and sometimes Germain Raingo and Jean Renoir, their hair cut *aux enfants d'Édouard*. There were also visits from Julie Manet, the daughter of Berthe Morisot and Eugène Manet, and her cousins Paule and Jeannie, the latter of whom would one day become Mme Paul Valéry. The Monet household had lost none of its love of parties, and the 6th of June, Saint Claude's Day, called for bonfires built on the pond in honor of Monet. And since there had been the *Papaver Moneti*, there had to be the iris called *Madame Claude Monet* and dedicated to Alice.

Like all families, the Monet-Hoschedé clan rode the pendulum of life as it swung back and forth between catastrophe and simple joy. Among the crises that shook them were Michel's automobile accident, the flood of 1910 that devastated part of the gardens, the financial follies of Jacques, and the departure of the Butlers for America, along with the deaths of Mallarmé, Berthe Morisot, Sisley, Pissarro, and Cézanne, and of Suzanne and Jean. Then there were Theodore's remarriage, this time to Marthe, and the murder of Uncle Rémy by his *valet de chambre*.

The two events that dominated all others at the end of the century were, for Monet, the creation of the water garden and, for Alice, the death of Suzanne.

Then, during the time that Monet was completing his *Cathedral* series, contemplating a journey to Norway, and creating his pond, the dealer Ambroise Vollard opened the first exhibition of a young Spaniard, Pablo Picasso, whose work would shatter all received conceptions of painting for the next three-quarters of a century.

Facing the garden, on the far side of the railway tracks, in the meadow crossed by the Rû, slumbered a tiny marsh full of iris and waterlilies. Monet bought the bog, swapped some plots, and enlarged the body of water, embellishing its rim with an entire colony of aquatic plants capable of adapting to Giverny's climate. A system of sluices would soon begin to sweeten the pond with water from the Rû, and since there was no current to disturb them, the fragile, exotic, delicately colored nympheas joined their indigenous cousins to float silently on the water's still surface. Monet then had it spanned from edge to edge with a single-arch bridge whose pier-free curvature may have been inspired by a bridge in a Japanese print. The pond, like the garden, became a subject for painting. But to Monet's eye and for the purpose of his *Water Landscapes*, the pond quickly proved too small and, moreover, too rectangular. Thus, the artist acquired another parcel of land bordering on the Rû with the idea of changing its course, the better to enlarge the pond and modify its shape.

The Prefect to whom Monet submitted his plan reacted favorably, but the village took a strongly negative view of the project. Laundresses and peasants pasturing their cattle in the riverside meadows feared that the alien plants would overrun the banks, make the water inaccessible, and poison the herd. But after deliberation, the municipal council authorized Monet to alter the water's course.

For the Monet household, the tragic event of the last year of the old century was the death of Suzanne. Alice's third child and the wife of Theodore Butler contracted paralysis soon after the birth of her daughter, Lily, and her condition deteriorated so rapidly during the next five years that Jim,

Déjeuner du 12 novembre 1912
Hors d'œuvre
... sauce hollandaise ou crevette
... de chevreuil Chasseur
Dindes rôties
... à la moelle
Buisson d'Écrevisses
Pâté de foie gras
Salade
Praliné
Glaces Nelusko – Alhambra

her son, was entrusted to his Monet grandparents and brought up by Marthe, who would later become his stepmother. The young woman went into her final decline while Monet and Alice were in Paris for a while following their attendance at the funeral of Alfred Sisley. On returning to Giverny they found Suzanne very weak and tired. That night, the 6th of February 1899, she died in her sleep.

Alice gave way to a despair that bordered on unnatural grief. Every morning at dawn she visited the cemetery. Although he gave Alice every care, Monet felt helpless in the face of his wife's inconsolable state. Whenever he went on a painting trip she wrote him such incoherent letters that he would drop everything and return home. Monet even repurchased for her a portrait of Suzanne by Henner, which as art he must have detested. He also took his wife to London, but her gloom persisted, and no one knew what to do about it.

Fortunately, Monet could keep busy with his plans for transforming the pond, and what with the problem of the village's resistance, the whole project became the focus of his every conversation. Then, they all began talking about an automobile.

A born urbanite converted to life in the country, Monet had never had anything to do with harnesses or carriages and harbored no interest whatever in horses. Nor was he in any great hurry to own an automobile. The boys, however, had grown up with cars powered by steam, gas, or electricity, and such terms as *tonneau, double-phaéton, torpédo*, and the names of their inventors resonated, for them, with as much romance as the names of medieval knights. This was the era when Amédée Bollée, Dion-Bouton, Renault, and Delamare-Rebouteville were making their discoveries, in the wake of still earlier pioneers.

A winter stroll about the pond: Monet, Theodore Butler, William Hart, Jim Butler, and Alice Monet.

opposite: At Giverny on November 12, 1902, Germaine Hoschedé married the Monegasque attorney Albert Salerou and moved into "Les Brighières," which made her a close neighbor of Renoir at Cagnes in the South of France. Menu for the young Salerous' marriage feast.

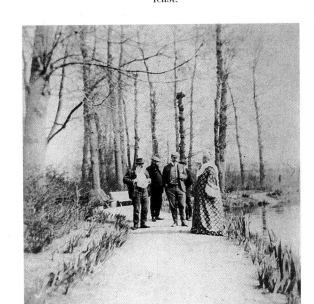

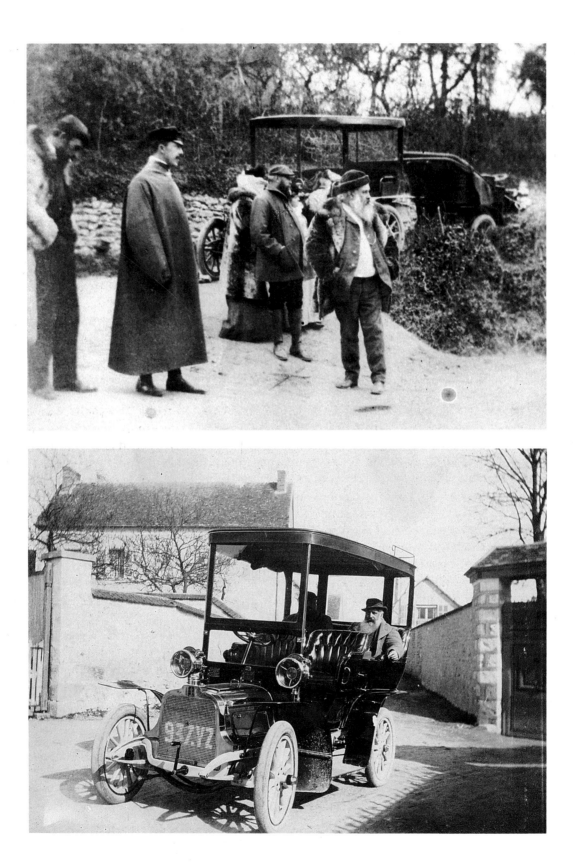

When the first Panhard-Levassor arrived in Giverny in 1901 Monet was away in London working on his *Thames* series. Frankly disappointed at not being there to receive the machine, he had secretly counted on this marvelous toy as a device for lifting Alice out of her silent desolation.

Having never learned even to ride a bicycle, Monet did not bother to learn how to drive a car. Instead, he hired a chauffeur who already had his "Certificate of Competence to Drive Petrol-fired Vehicles" (subject to revocation after two citations within one year). This good man now took charge of the "937-YZ." It was the fashion to call an automobile by its registration number, as Mirbeau would later do in his unforgettable "628-E8."

Nestled behind the open driver's seat, muffled up in fur cloaks brought from Norway by Monet, coiffed in toques, gloved to the elbows, and their eyes protected by thick goggles, Monet and his folk enthusiastically took up the "automobile sport," for outings and work alike. The artist had himself driven to his motif, especially for the second series he did at Vétheuil.

Monet's hunch had paid off, for Alice, it turned out, would love speed and led the way in planning escapades in the new vehicle. When the second Panhard-Lavassor appeared in the garage, then Jean-Pierre's Hotchkiss and Michel's Bonnet-Zedel, a veritable caravan developed, laden with passengers, chairs, and a great wicker basket filled with enough victuals to sustain a siege. The Monets were on their way to a picnic.

Any pretext would do, whether it was going for lunch with Jean and Blanche in Rouen, joining Butler while he was painting at Yport, Veules-les-Roses, or Pourville, or even traveling all the way to Lamotte-Beuvron, beyond Orléans, to taste the new upside-down apple tarte invented by the Tatin sisters.

They also took in the races at Gaillon, where a Benz broke every record for several years running, climbing, despite its being only 40 horsepower, the thousand meters in 47.10 seconds. Nor did they miss the fireball cars as they passed through Beauce in the Paris-Madrid race. Another irresistible temptation was an excursion to witness the equinoctial tide, that immense wall of water that rapidly rolls in across the entire mouth of the Seine. Announced by a terrible roar of water all the way from Quilleboeuf, the boom at Caudebecq-en-Caux arrives with thunderous, earth-shaking violence.

Furthermore, Monet and Alice had themselves driven to Spain, a journey decided upon at the last minute and mainly for the purpose of seeing the paintings of Velázquez. Despite several mechanical problems and two stops at the "Villa Marie," they completed their Giverny-Madrid round trip in three weeks, with, admittedly, part of the distance covered by train. After marveling at the Prado, which he visited for the first time only in 1904, Monet left immediately to continue his painting in London.

The automobile changed everything, from the rites of hunting for game to the gathering of mushrooms. Now it was the automobile "salons" that turned everything topsy-turvy. The "937-YZ" gave way to a limousine for Monet, to be followed in turn by a second Panhard. When this disappeared it made room for a "Zebra," the little wagon into which one squeezed to go marketing on Saturday.

opposite above:
In 1904, as in every year at this time, the entire speed-loving Monet family piled into their automobiles and went off to watch the "fireball" cars race at Gaillon.

opposite below: Monet, who never touched a steering wheel, and Theodore Butler awaiting their chauffeur, Sylvain.

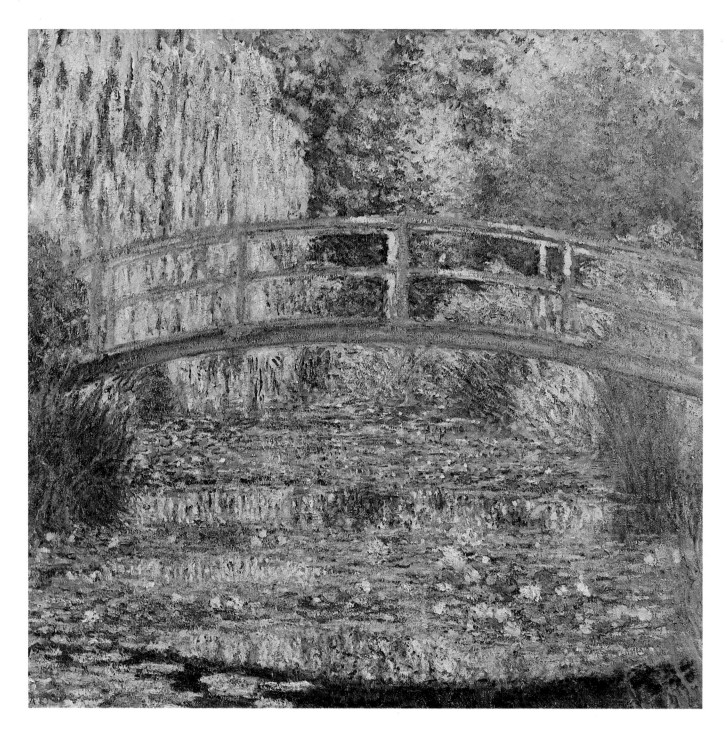

Le Bassin aux Nymphéas, Harmonie Verte (Lily Pond, Harmony in Green). 1899.
34¾ x 36¼″ (89 x 93cm).
Galerie du Jeu de Paume, Musée d'Orsay, Paris.

Le Bassin aux Nymphéas, Harmonie Rose (Lily Pond, Harmony in Rose).
1900. 34¾ x 39″ (89 x 100cm).
Galerie du Jeu de Paume, Musée d'Orsay, Paris.

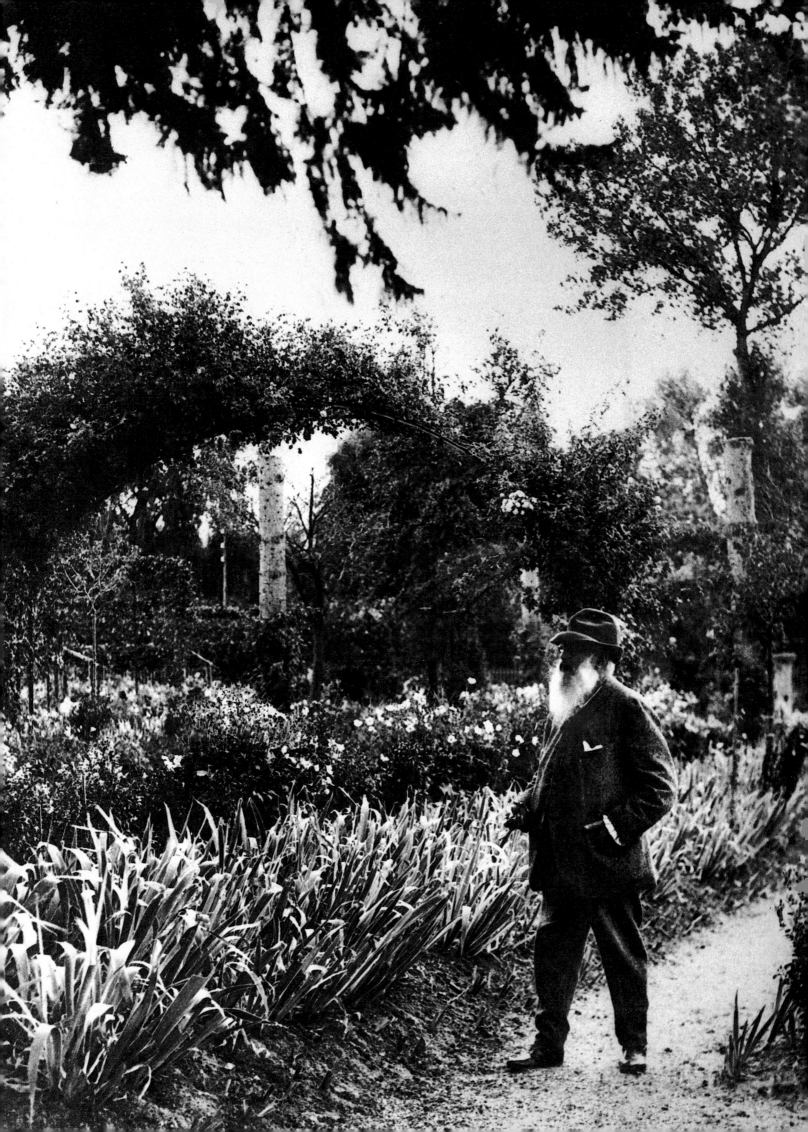

Monet and His Friends

Monet did not attract those hordes of hangers-on who so often come with glory. While in no way negligent in his relations with others, he mainly cultivated his true friends. The world of plots and intrigue was foreign to him, and he viewed all such strategies as rather unsavory forms of infantilism.

At Giverny, the rumors circulating about Paris reached Monet by way of newspapers, books, and mail. And he had feared he might be too removed from the capital. However, he went there for exhibitions, to talk "Japanese" with the Desoyes, to meet Renoir, Helleu, and Mirbeau at the Dîner de Bons Cosaques or join in the rowdy banquets arranged by the Impressionists. On these monthly occasions, critics, writers, and often Mallarmé came together with Sisley, Renoir, Caillebotte, and Pissarro at an excellent meal prepared for them at the Café Riche. Free like prep-school boys drunk with the first day away from classes, they threw themselves wholeheartedly into roaring, endless discussions of art, politics, and philosophy. Monet had an overriding passion for literature, and in the course of these dinners a veritable tournament would develop for or against Victor Hugo, arousing tremendous animosities that, while short-lived, could very well continue outside along the boulevards, sometimes in follow-up letters. Caillebotte, commenting on Flaubert, asked: "Could anyone like George Sand?" Both Mirbeau and Mallarmé had discovered Maeterlinck, whom they urged Monet to read. Even while keeping Delacroix's journal at his bedside, Monet had plunged into Tolstoy and Ibsen and begun to reread Maupassant.

To please Alice, Monet took her to wrestling matches as well as to concerts. The couple also kept up their ties to several composers, such as Chabrier, a friend of many painters and a collector of Impressionist pictures. The Monets were to be seen at numerous opening nights, never missing those of Mirbeau's plays. They were there for the first performance of *Chantecler*, in which their friend Lucien Guitry played the role of the cock. They left their seats at the Théâtre Antoine to take places in a box at the Opéra to hear Chaliapin. Monet and Alice saw Pavlova, and nothing could have kept them away from Loïe Fuller doing her *danse serpentine*. Afterwards, they would dine at Prunier's or the Marguery, sometimes with success in extracting a recipe from the house. All this was a far cry from the time when Monet, living in Paris, had frequented such squalid eating houses as Monsieur Fromage, where the main dish was concocted from cheese leftovers, or other restaurants in the Rue de Rennes with customers so desperately impoverished that the cutlery had to be chained to the tables.

Once back in Giverny, Monet changed from his city togs into his country uniform. Stored away in boxes and trunks were scarves and caps for every hour, but usually a beret or a felt would do. And for painting out of doors, the artist would sometimes wear sabots.

Monet dressed in sober English tweeds cut in a style known only to himself, with a touch of dandyism in his preference for pleated batiste shirts, always in some pastel shade, with cuffs long enough for their narrow pleats partially to cover the hands, and a jabot, also pleated, which freed the painter's neck from the necessity of a tie. Three buttons caught up the bottom of each trouser leg to reveal a pair of fine leather boots, which, albeit made to order by a cavalry supplier in Vernon, had nothing military about them.

This was how Monet looked when he received his friends, among them his sole Givernois intimate, the excellent botanist Abbé Toussaint, his old acquaintances from Le Havre, his Japanese

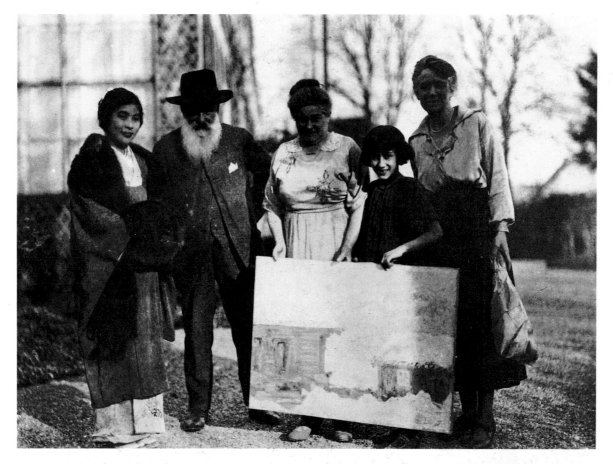

There were many Japanese among the early admirers of Impressionist painting. Monet, however, would not let them acquire certain of the pictures in his Waterlily series. Here, Mme Kuroki, *née* Matsukata, had just bought a painting, before posing with Monet, Blanche Hoschedé-Monet, Nitia Salerou, and Germaine Hoschedé-Salerou.

right: Protected by a large umbrella, Monet works at his waterlily studies. The ever-present Blanche changed the canvases on his easel, in a sequence dictated by the mutating light. Here, Nitia Salerou stands in the foreground.

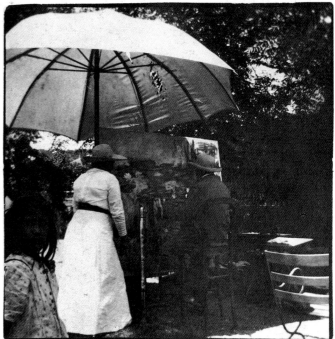

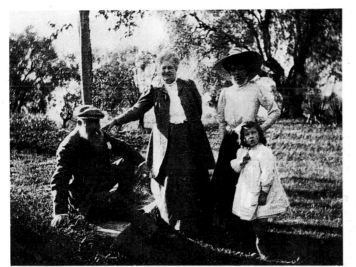

left and below:
On December 12, 1908, while returning from Venice, Monet and Alice spent several days with the Salerous in Cagnes, where they also had an occasion to visit Renoir at the villa "Collettes." Monet with Alice, Germaine Hoschedé-Salerou, and Sisi Salerou.

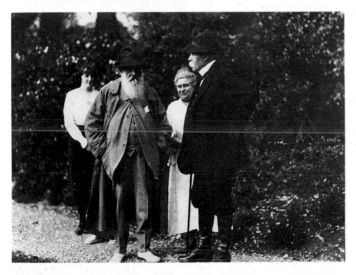

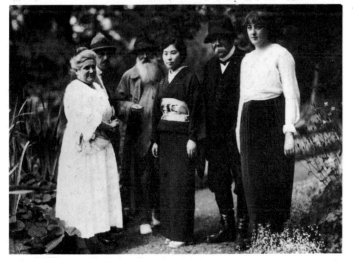

left center and below: June 1921, the ritual after-lunch walk through the water garden. On this occasion the guests were the Kurokis, Monet's Japanese collector-friends, Clemenceau, and Lily Butler, the latter recently returned from the United States. The Kurokis often sent Monet peony bushes and lily bulbs that were rare even in Japan and totally unknown in France. Here Monet's party has been joined, on the left, by Blanche Hoschedé-Monet and Clemenceau.

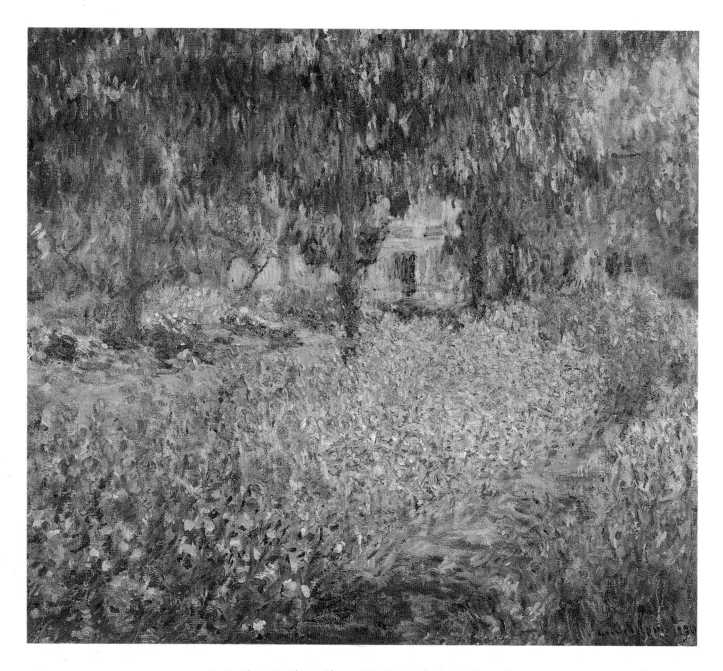

Le Jardin de l'Artiste à Giverny (The Artist's Garden at Giverny).
1900. 31⅝ x 35⅞″ (81 x 92cm).
Galerie du Jeu de Paume, Musée d'Orsay, Paris.

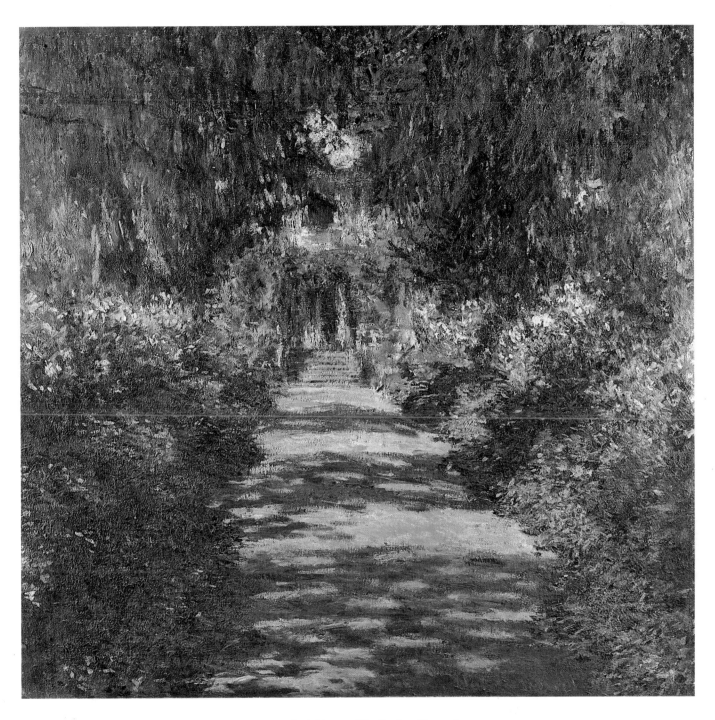

Le Jardin à Giverny (The Garden, Giverny).
1902. 34¾ x 36″ (89 x 92cm).
Kunsthistorisches Museum, Vienna.

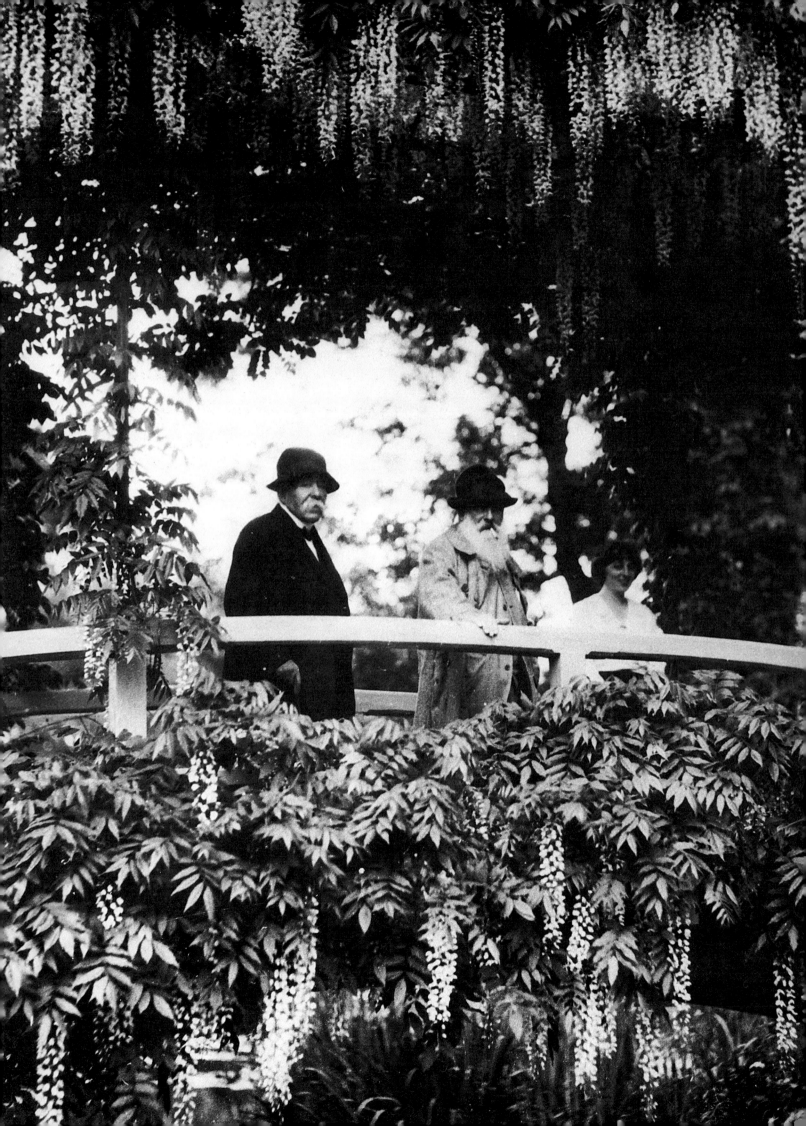

connections, especially M. Hayashi, and such Japanists as Whistler, Duret, and the Goncourts. Then there were the Londoners, Sargent and his friend Mrs. Hunter, and such "provincials" as Mirbeau (the coiner of the term) and his wife, in addition to the Parisians Rodin, Thadée Natanson of *La Revue blanche*, Lucien and Sacha Guitry, the latter's wife, the actress Charlotte Lyses, Ajalbert, and Paul Valéry. Paul Durand-Ruel and his family, despite a few misunderstandings, would always retain a special place in Monet's affections. But the artist also saw the Bernheims occasionally, and Clemenceau as well as Geffroy virtually all the time. Also in regular touch were all his friends in painting: the Pissarros, the Renoirs, the Sisleys with their children Pierre and Jeanne, Berthe Morisot and her daughter Julie Manet, and Caillebotte, who would arrive at random, traveling down the Seine on his yacht, the *Casse-Museau.*

Geffroy was the only critic whose opinion really counted with Monet. But the artist prided himself on having compiled an unprecedented collection of reviews, even though unfortunately reduced by losses incurred during moves and the various seizures. He had saved a considerable number of articles vilifying him and his friends, and when in a sly, ironic mood he would enjoy recalling one of Jules de Goncourt's *mots*: "Nothing and no one ever heard so many stupidities as a picture."

Mirbeau, who cultivated a choice selection of flowers, paradoxes, and friendships with equal bliss, and all but worshipped Monet, lived as his ancestors had for centuries at the Château de la Madeleine near Vernon, at Sainte-Geneviève, or Les Demps. When he did not call, he wrote letters, without always remembering to post them, and despaired at the sight of his flowers spoiled, as they often

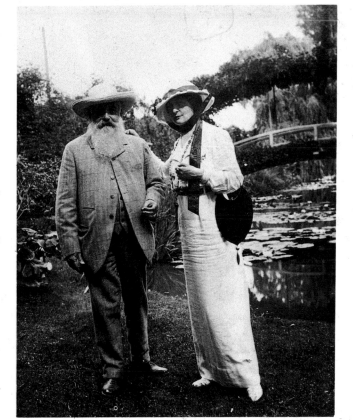

opposite:
June 1921, with Clemenceau, Monet, and Lily Butler on the Japanese footbridge when the two wisteria vines, one white and the other mauve, were at their fullest.

left: In 1913 Monet received a visit from the American opera singer Marguerite Namara, who insisted upon performing for the master in the water garden.

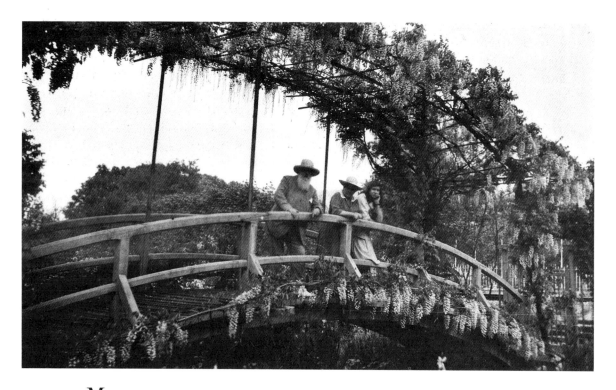

Monet, Blanche, and Sisi Salerou, the artist's granddaughter by marriage, on the Japanese footbridge, now overarched by a trellis festooned with Chinese and Japanese wisteria.

were in Normandy, by rain and wind. Monet, when caught up in his work, dreaded Mirbeau's constant attention, but could not resist such exhortations as: "Yes, Monet, let's love something so as not to perish, to save ourselves from going mad! But I don't think we need to give ourselves advice, for should we ever go mad, it will be from loving too many things."

The regulars at Giverny came to have lunch at an exceptionally good table, to remain a few days, talking gardens, visiting the hothouse, examining the latest canvases in the studio, taking photographs of the pond, borrowing a book, and discussing another. In sum, they brought a bit of intellectual life to the country, where it was not often found. In this way they provided a vital link between what was happening, being written, or painted in London, New York, and Paris and the hardworking world at Giverny.

When the Monets took lunch or dinner out of doors, it was at a table set on the "balcony" under a cover of climbing roses, and on those occasions the artist would always sit facing the garden on axis with the *grande allée* and the Japanese bridge. Thus, even while talking with his guests, he missed none of the shifting light as it played over the flowerbeds.

Sometimes in these moments of relaxation among close friends, Monet could catch fire and, if urged, relive old memories. However, he never expressed much feeling for his childhood or family, other than his Aunt Louise, who, as something of a painter herself, was closer to him. Although she viewed her nephew's pictures as hopeless, this good woman supported and sheltered Monet and even gave him a small Daubigny that he coveted.

Monet never passed judgment on people; he only implied his opinion of them by his tone of voice. He would speak of the difficult periods in his life calmly and without regret. He talked about Manet, about Frédéric Bazille, who had been Jean's godfather, and about the colorful crowds and strange

animals he had seen during his military service in Algeria. Monet told of the evenings spent at the Brasserie des Martyrs, bringing vividly to life the excitement of those days of struggle and partisanship. Here he had met all the bohemian world of Paris, artists of every caliber, good and bad. Here for the first time he had seen Courbet, without daring to approach him—Courbet the magnificent, who would later lend him money as he lent it to everyone, and who kept open house in the Rue Hauteville for a horde of starvelings who would do little to support their old benefactor during the Vendôme Column affair. Imitating the older painter's pungent Franc-Comtois accent, Monet told of how one day when he and Courbet were in Le Havre at the same time they decided to call on Alexandre Dumas *fils* even though neither of them had ever met the great writer. When the landlady raised some objection about introducing them, Courbet cut her short by bellowing: "Tell him it's the Master of Ornans." But as Dumas finally appeared he and Courbet immediately fell upon one another and began using the *tu* form of address. Calling Monet *le jeune homme*, Dumas took them both into lunch and invited the pair for a meal the next day at La Belle Ernestine's. As the carriage bore them off to the Saint-Jouin auberge, the silent Monet was astonished at Dumas's verve. While Courbet was garrulous and racy, Dumas waxed witty and eloquent. The two great men saw one another often, and entertained themselves in Le Havre with singing and cooking! A long time afterwards Monet would return to La Belle Ernestine's in the company of friends, and on that day in 1916, when beautiful Ernestine had grown old and much less comely, she showed them a yellow, piously preserved telegraph sent by Dumas many years earlier bidding her keep *force crevettes*—"plenty of prawns"—for his guests.

Monet loved books on botanical subjects and owned a twenty-six-volume set of *Flore des serres et des jardins de l'Europe* (Ghent: Louis van Houtte, 1845), which he often consulted.

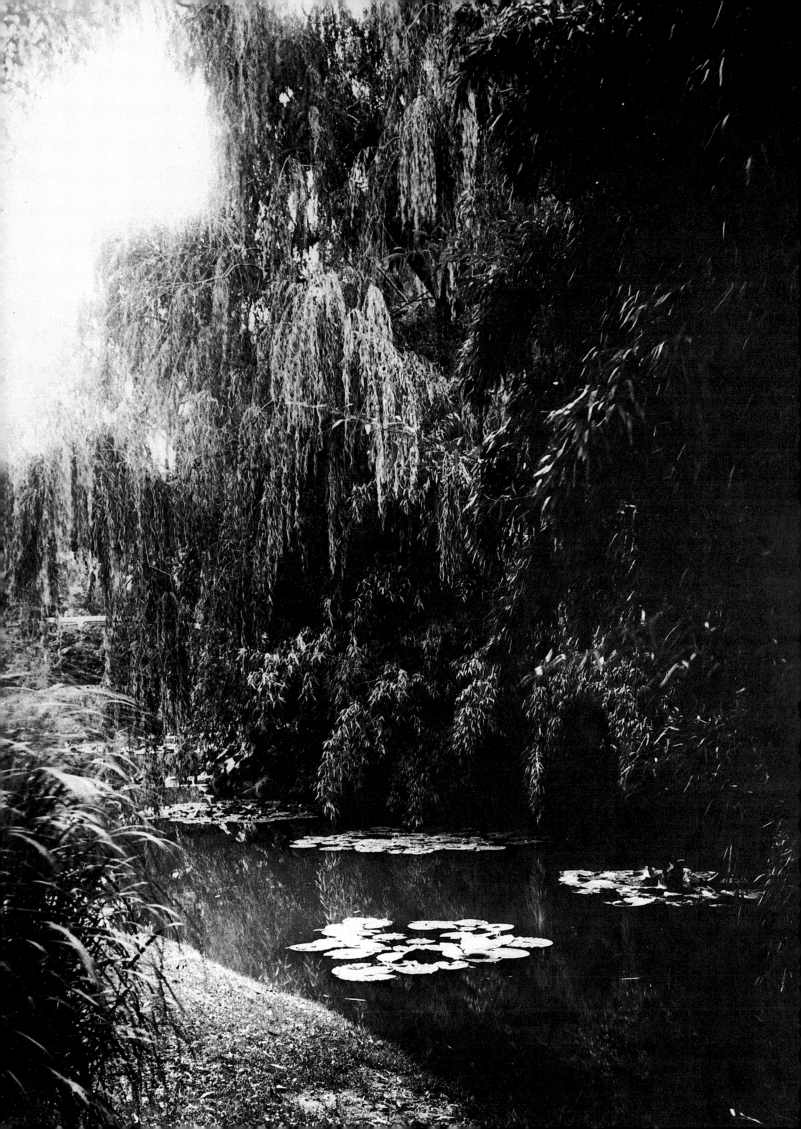

onet's House

Once through the gate, the visitor to Monet's Giverny domain could experience a rude shock at finding himself surrounded by a dense garden nestled within surrounding walls, only to have the environment slowly reveal its charms.

In 1897 Monet had an annex built near the lime trees, with space on the ground floor for a garage, the gardener's quarters, and a darkroom. Upstairs the artist installed apartments for Jacques and Inga and Jean and Blanche, along with his own main studio, lit by an immense northern window and finished on the south with a glazed balcony overlooking the hothouse. There, during the winter, the artist reviewed his work and finished his canvases, but without signing any of them until the last moment. On the walls hung, irrespective of chronology, pictures from every period, some of which he would rework several years in succession. Others were stacked and ready to be claimed by Durand-Ruel, the Bernheims, or some private collector. It was a spare room embellished with little more than a vitrine full of Japanese ceramics and a rolltop desk, on which stood a photograph of a self-portrait by Manet next to a letter from Stephane Mallarmé, a missive whose arrival seems astonishing in the light of this sybilline address:

Monsieur Monet que l'hiver ni	*(Monsieur Monet who cannot false be,*
L'été sa vision ne leurre	*Summer or winter, to his vision*
Habite en peignant Giverny	*Lives and paints at Giverny*
Sis auprès de Vernon, dans l'Eure.	*In the Eure close by Vernon.)*
Stephane Mallarmé	

After visiting the studios, Monet led his guests to the salon or his study. From the garden they would mount a few steps to enter the house illuminated by tall, wide French windows. During a period notable for interiors virtually choked with an overload of fringe and tassels, tapestries and heavy drapery, all designed to block out the despised sunlight, the barrenness of the Monet rooms came as a surprise. They contained little furniture, much of it merely painted. Rush mats and a few small Oriental rugs barely muffled the sound of feet, and the only luxury was to be found in the prints and paintings that covered every wall.

On the staircase visitors could see a Toulouse-Lautrec poster for Yvette Guilbert, a Kakemono color woodcut, and a reproduction of a print by William Hogarth. Upstairs, in the suite that he shared with Alice, Monet had hung his personal collection, which covered walls of the two bedrooms and their adjacent dressing rooms. Even though the display changed from time to time and never included everything, it could offer as many as twelve Cézannes, a Corot, four Jongkinds, three Delacroix, a Fantin-Latour, a Degas, two Caillebottes, three Pissarros, a Sisley, nine Renoirs, five Morisots, a watercolor by Chéret, two by Signac, a Vuillard pastel, and bronzes by Rodin. At one point Monet owned works by Manet and Sargent, whose watercolors he preferred to the oils. No one remembers having ever seen a Boudin, a Whistler, or a Courbet that Monet liked.

In the studio-salon, Monet had assembled his own paintings, works representative of every period. Some had been left as pledges against unpaid debts and then reacquired by purchase or exchange, while others were pictures the artist refused to part with, or simply "unsold" pictures, such as *Sunrise over Vétheuil*, which the operatic baritone Faure had rejected because, in his opinion, the canvas had too little paint on it. Monet had even tried, through Durand-Ruel, to buy back *The*

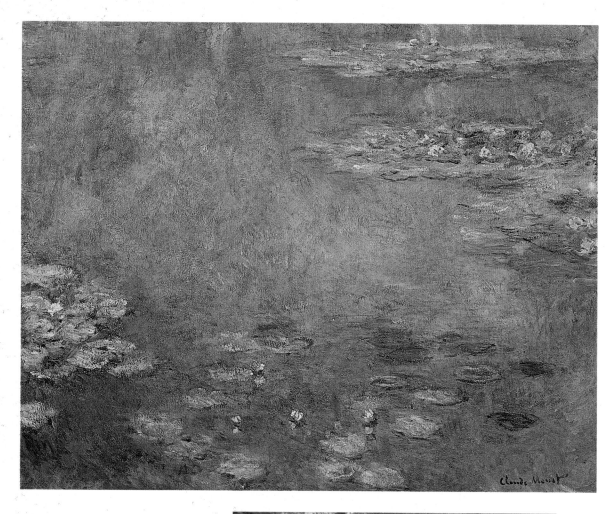

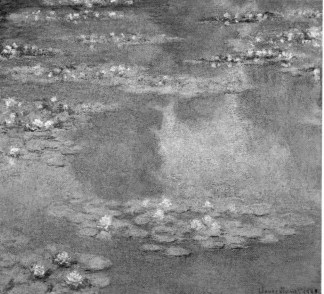

above:
Nymphéas (Waterlilies). c. 1906.
28 x 36″ (72.5 x 92cm).
Ohara Museum, Kurashiki, Japan

right:
Nymphéas, Paysage d'eau
(Waterlilies I). 1905. 35¼ x 39½″
(89.5 x 100cm). Museum of Fine Arts
(gift of Edward Jackson Homes),
Boston.

opposite:
Nymphéas, Paysage d'Eau
(Waterlily Pond). 1907.
44¾ x 29″ (101.5 x 74.5cm).
Bridgestone Gallery, Tokyo.

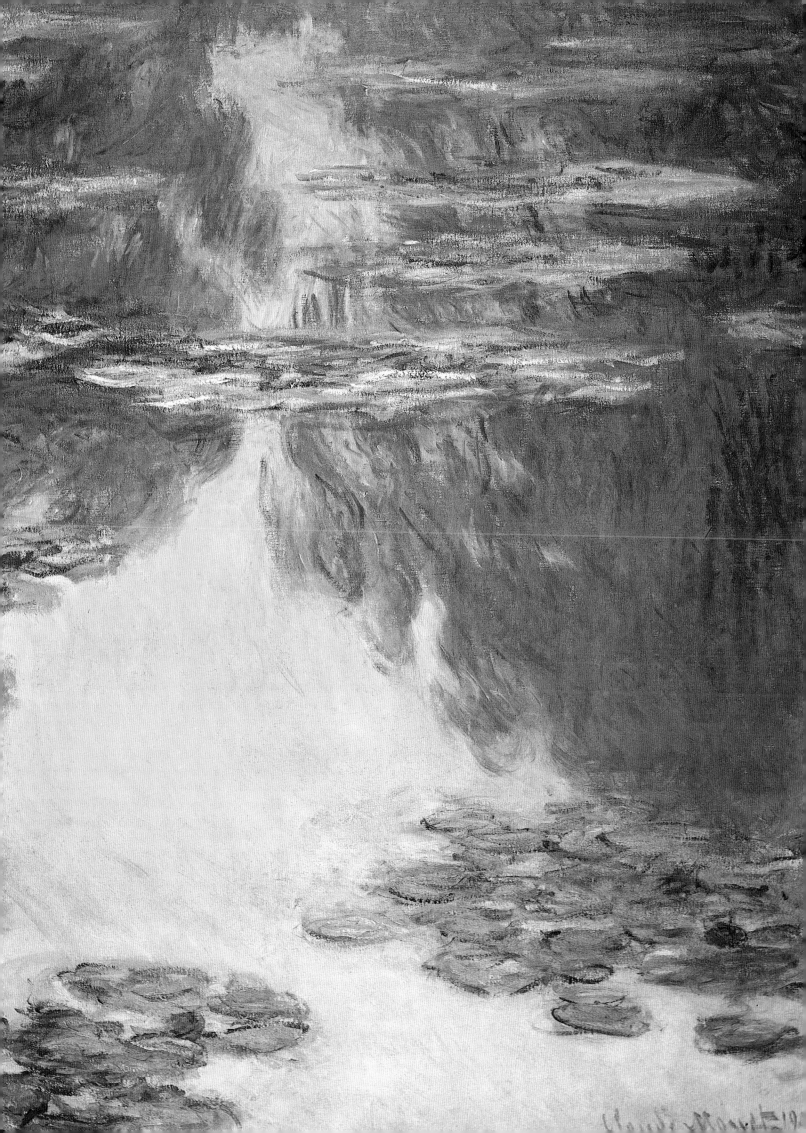

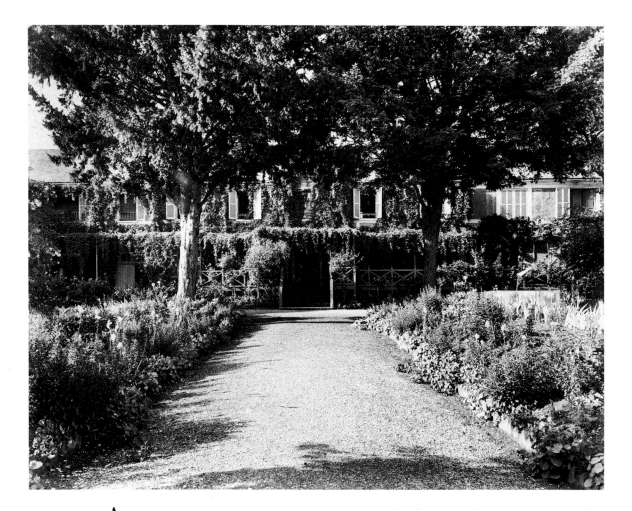

At the head of the sand-raked *grande allée*, a pair of yews—survivors from days before
Monet's arrival—partially hid the house, now so thickly overgrown with Virginia creeper that the
vines fall back to provide a veritable roof shielding the "balcony," where the painter, his
family, and their friends took lunch during the summer.

White Turkeys, one of the Montgeron decorations, but then gave up the idea, probably because of
the price. He did not, he once said, want to play the turkey himself in some farce.

Hung edge to edge in three tiers, the collection overlooked chintz-covered wicker chairs, couches,
and chaises-longues, and it recapitulated the various stages in the artist's career and travels, from
Belle-Île to The Netherlands, from Christiana (Oslo) to Venice, from Fresselines to Pourville, Bor-
dighera to London, Étretat to Antibes. Together the pictures made a veritable storehouse of mem-
ories, each work indissolubly bound up with some cherished association: the meeting with Geffroy
at Belle-Île when the writer inquired whether Monet was preparing for the Salon and whether he
knew Raffaelli, the evenings in London when Monet dined with Whistler and found Sargent in his
Chelsea studio playing Wagner on the piano.

The ceramics in the vitrines or on the mantelpieces, the prints hung in the stairwell of the sec-
ond studio, in the mauve salon that served as a library, or in the dining room spoke of Monet's taste
for everything Japanese, a fashion among the intelligentsia and the avant-garde throughout the
period. The artist even owned sketchbooks by Utamaro and Hokusai.

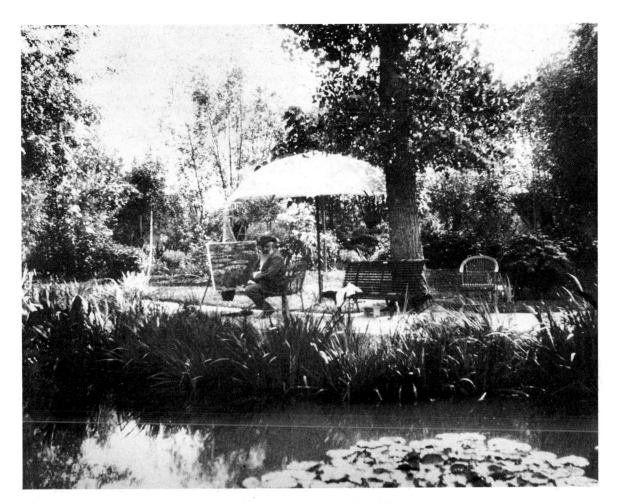

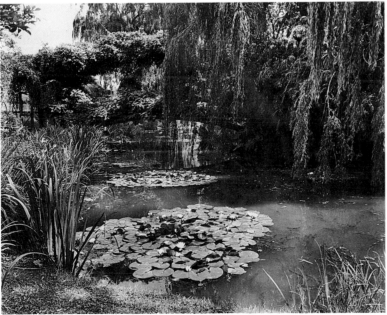

Monet at work on one of his waterlily studies in the water garden near a large copper beach, the only red-leaf tree allowed within that sacred realm.

left: The western end of the water garden at its peak, when the bushes, iris, grasses, waterlilies, and wisteria had reached their lushest growth.

London had discovered Japanese art two centuries before the Perry expedition. Then in the aftermath of this historic event, English, Dutch, German, and American travelers had been returning with and passing around sketchbooks and objects. In France, Cernuschi and Duret had long been circulating volumes of color woodcuts by Utamaro and Hokusai and drawings by Ogata Korin. Familiar with London since 1870 and Holland since 1871, where American ships came into port en route from Japan to the United States sometimes ballasted with cheap Japanese prints, Monet had quite early on seen the kind of Japanese color woodcut that the entire West would soon be collecting. The prime opportunity for introducing such works, this time of high quality, came with the Universal Exhibition of 1867.

The blue and yellow color scheme used throughout the house culminated in the dining room, its walls, ceilings, and chairs painted in two tones of yellow and brightened by blue Chinese, Dutch, and French ceramics displayed between a pair of silver cabinets. Near the precious silver samovar stood

The *grande allée* vaulted by rose-entwined trellises and so choked with nasturtiums that visitors had to zigzag in order not to step into the rampant growth.

opposite: A cluster of bamboo growing in the water garden. Note also the boat used by the gardener who worked full time to maintain Monet's pond and its flowering, gladelike environment.

the blue Willow Ware, a French imitation of Japanese ceramics, which served for everyday use, but gave way on grand occasions to a large service in Marly porcelain whose yellow color and blue border matched the overall décor elsewhere.

As for the prints of Hiroshige, Utamaro, Hokusai, Kunisada, and Eishiou Toyokuni, to cite only a few in an extensive collection, they were simply mounted under glass in strip frames of raw wood and arranged on the wall at rhythmic intervals set by Monet himself.

When visiting Monet, no one went home without first touring the gardens and hothouses. The space originally occupied by the orchard had survived, along with the yews and limes, but little by little Japanese flowering cherry and apple had replaced the old fruit-bearing trees. Meanwhile, an iron trellis laced with climbing nasturtiums and roses clung to the wall along the Chemin du Roy as far as the eye could see. Thanks to enormous sums spent on the flowerbeds, the inhospitable, but constantly enriched, soil had finally been tamed. Until 1892 Monet, helped by the children and a few gardeners hired by the hour, had cared for the garden himself. But as the flowers took over more and more space, they gradually required work beyond the artist's ability to cope. And so once income from his art permitted, Monet employed a head gardener, a man recommended by Mirbeau, as well as five assistant gardeners, one of whom was responsible solely for maintaining the pond.

Monet gave daily directives, and checked several times a day to make sure they were being carried

Pivoines (Peonies). 1887.
28½ x 39″ (73 x 100cm).
Galerie Beyeler, Basel.

opposite above:
Glycines (Wisteria). 1920–25.
4′10½″ x 6′6″ (150 x 200cm).
Gemeentemuseum, The Hague.

opposite below:
Les Iris Jaunes (Yellow Iris).
c. 1920. 4′3″ x 4′11¼″ (131 x 152cm).
Musée Marmottan, Paris.

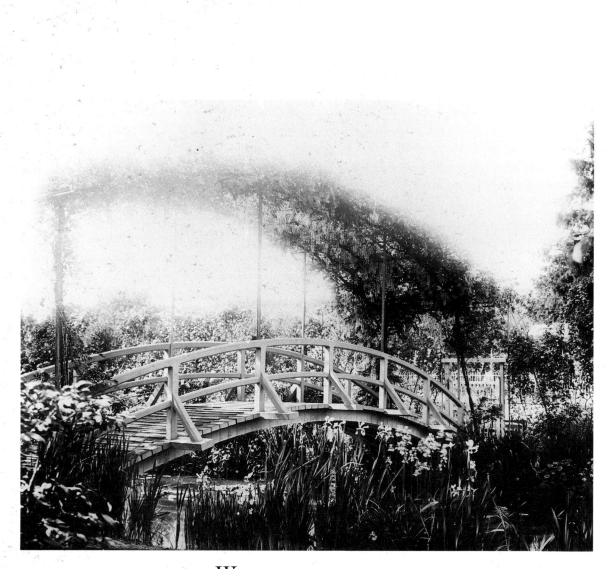

Water iris near the Japanese bridge.

opposite: Large, round leaves of sweet-scented coltsfoot tumbling into the water.

out. Nothing escaped his attention. He straightened a form, corrected a perspective, recomposed a clump of flowers, and had fading blooms culled from the whole. As in his painting, he allowed high-key colors to dominate and juxtaposed them in large, monochrome masses. Little or no bare ground remained, so concentrated were the plantings of simple flowers and pure green foliage, elaborated only by brier roses and star-shaped dahlias with fluted petals.

Sometimes the discussions between Monet and Breuil, the head gardener, could become rather heated. While Breuil argued for chalky soil, plenty of space, and pruning, all of which Monet appreciated, the latter cared more for color relationships, density, and texture. Together the two men produced a veritable cavalcade of flowers from early spring onward. The blossoms covered the ground, grew in clusters, masses, and cascades. There were bowers of roses and arches of clematis, with creepers everywhere twining about the trunks of trees.

In summer the orange stems of a Virginia jasmin ventured up the nearly blind wall parallel to the upper road. From there the eye fell upon a veritable sea of surging flowers, surrounded by sinuous, almost rampantly dense borders, where annuals and perennials crowded together until they had all but devoured one another.

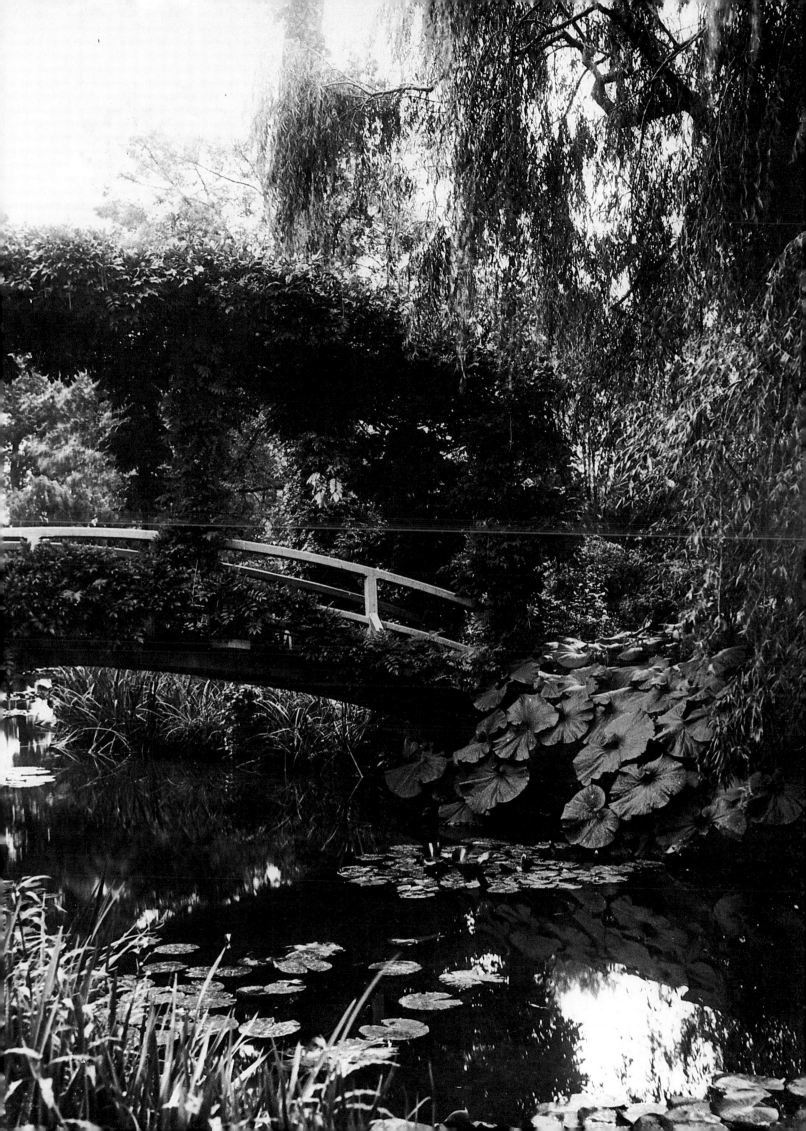

Although the layout of the flowerbeds was geometric in plan, Giverny had nothing of the formality typical of French gardens. Squares and rectangles disappeared under the spreading lushness of borders mixed of nasturtiums, wild geraniums, aubrietia, and pink saxifrage. Monet's was a painter's garden, where everything conformed to a certain rhythm, the graceful tall stems of iris, lilies, foxglove alternating with great plumes of grass and the supple abandon of poppies, followed by wild harmonies of fawn, crimson, saffran, and blue. These, in turn, played against the equally contrasted foliage—the scalloped leaves of acanthus and the tapering spikes of lupin, with their variously mat and polished greens. Even the shallow furrows in the blond paths of raked sand were not chance effects.

Transcending the apparent disorder was an orchestrated movement, tuned to the slightest variations in either the terrain or the play of light, and opulent enough to allow a subtle interweave of volunteer species. As early as January the garden would come alive with yellow jasmin, Christmas roses, snowdrops, and scillas, which heralded the spring crocuses, the first primroses, and the successive waves of tulips and narcissi. Monet would eagerly watch the young shoots thrusting up through the dormant earth, but while longing for a more exuberant spectacle, he had only to visit the hothouse, in whose moist, luminous atmosphere the many varieties of orchids gave out a heady scent. Hanging roots interlaced overhead, mingling with the fragrance of the luxuriant miniature jungle of sensitive plants, ficus, and parasitic ferns clinging to the bare mossy stems of dwarf trees. Glowing Korean chrysanthemums and the strange ruffled crests of strelitzias bloomed beside a small pool of frail African waterlilies.

The way to the pond led down the *grande allée* as it unrolled toward the wrought-iron gate in the lower crescent walls. Having crossed the Chemin du Roy and mounted a brief rise, Monet and his guests had to trespass upon—no less—the property of the Compagnie du Chemin de Fer de l'Ouest and then step over the rails of the little "twister" train.

The pond, like the garden, had been originally conceived for the delight of the eye, but gradually it acquired greater importance as a subject for painting. When finally permitted to divert his branch of the Epte, Monet proceeded to remodel the little pond, enlarging it repeatedly and curving its edges as he pleased. Thus, with the help of meandering paths and clumps of trees, he managed to create the effect of a relatively vast space. Now the Japanese bridge was laden with white and mauve wisteria. Close by stood a rustling grove of bamboo, its tall stalks noisy with starlings, while over the banks of the water grew a thick array of iris, spiraea, and the circular leaves of sweet-scented coltsfoot. All about flourished a profusion of roses—bush roses, standard roses, and that bold rambler called *Belle Vichyssoise*, which climbed like a liana around the trunks of trees. Huge ferns jostled great masses of rhododendrons and Japanese azaleas. As weeping willows leaned into the pond, yellow, white, purple, pink, and lavender nympheas bloomed in late spring and continued flowering throughout the summer.

When Monet created the water garden he most likely did not suspect that it would become an inexhaustible source of inspiration for over thirty years. To the very end of his life, however, he would paint its every aspect, at every hour and in every weather. Indeed, that sheet of tranquil water, with its shimmering surface supporting a resplendent botanical growth and revealing another in the transparent depths, would become a mirror that totally absorbed Monet. He was to work at hundreds of paintings and studies there, like the Japanese artist who never, throughout his life, tired of painting the same garden. So intimately did Monet become bound up with his lily pond that it would be impossible to say where the gardener's work stopped and the painter's began.

Dame Blanche, Clemenceau, and the Nympheas

Alice died on May 19, 1911. Even the blind Degas tapped his way to Giverny to pay his last respects to a lady who had received them all with such enormous kindness.

Monet simply collapsed, and for months remained totally indifferent even to things that had meant the most to him. He deserted the studios and the gardens alike. After years of insisting upon a brilliant table, he all but lost interest in food.

The poor broken man spent hours on end reading and destroying letters. This was how Marthe would find him every morning, when after seeing to her own household, she took charge of the Maison du Pressoir, a responsibility assumed by Geneviève after lunch. Marthe looked after the correspondence, which Monet allowed to pile up. Suddenly annoyed that he had become a boor, the elderly master then fell back into self-mockery and would write only incoherent and despairing letters to his friends and children.

In the autumn, to everyone's relief, Monet finally wrote to Durand-Ruel: "Winter is coming, and I couldn't bear to remain inactive during these dreary days. I shall first try to finish some of my paintings of Venice." But he lacked the heart to do this in the presence of the motif, as had often been his wont. And when the exhibition of the Venetian pictures opened, Monet confessed to Durand-Ruel: "... More than ever today, I realize how artificial is the undeserved fame I have won. I keep hoping to do better, but age and sorrow have drained my strength. I know beforehand that you'll say my pictures are perfect. I know that when they are shown they will be much admired, but I don't care because I know they are bad. I'm certain of it. Thank you for your comforting words, your friendship, and all the trouble you have taken. I hope to see you next Sunday for lunch as usual. . . . "

Monet more or less deserted Drouant's restaurant, where a place had always been kept for him at the table reserved for the Académie Goncourt. He also gave up painting trips, and when he resumed working, it was in semisolitude. Visits from friends and the presence of strangers left him unsettled. Occasionally he would go to Paris for the Colonne concerts or for dinner with Vuillard, Roussel, or Chéret. He also came to know Bonnard, who had taken up residence in the neighboring village of Vernonnet and whose friendship assumed a special importance at the end of his life. Later, while working on *The Large Decorations*, Monet had several visits from Matisse. He even resigned himself to a long day in 1913 when the American singer Marguerite Namara insisted upon singing for him. Playing the good host, Monet gave the lady a guided tour of the gardens and studios, while Butler had his piano moved to the pond. With Sacha Guitry acting as photographer, the artist posed for a double portrait with his operatic admirer.

Meanwhile, the symptoms of double cataracts that had first appeared in 1908 now became acute. Degas and Mary Cassatt were already blind, and Monet feared that he too would lose his sight or find his vision radically altered should he undergo surgery, which for the moment was prevented by therapy. Distressed by his friend's anxiety, Clemenceau kept pestering Monet and by doing so managed to heal what Mirbeau called the artist's "paralyzing moral rheumatism." The statesman issued invitations, sent a backgammon set, and, finally, after endless discussion, forced Monet to go on a holiday. Thus, accompanied by Michel, Jim, and Lily, he departed for Lucerne, Saint-Moritz, and Davos. Outings on the little mountain trains, the long walks, the landscape all filled him with eagerness to return to Switzerland the following year with his easel and canvases. Before that could happen, however, war broke out.

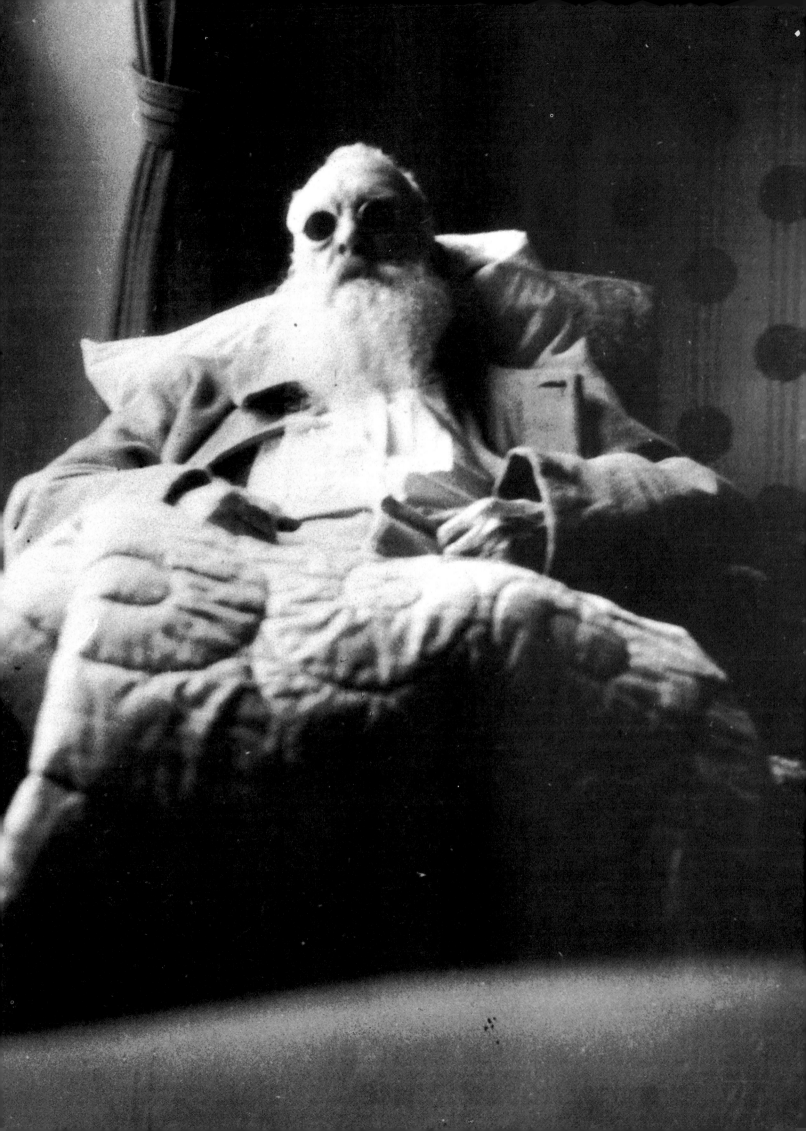

Simultaneously, Monet had severe trials to endure within his family. A lifelong antagonism finally made him break off with his brother forever. Then, Jean became so ill with a nervous disease that he and Blanche moved into the Maison du Pressoir. At times silent and withdrawn, at others incoherent and rambling, Jean showed little awareness of reality. Monet found himself so taken up with the care of his son that he rarely dared to leave Giverny. It was a harrowing period for both wife and father, one that left the artist as depressed and gloomy as he had ever been. The end came on February 10, 1914, when Jean died at the age of forty-seven.

Alone with Michel, Blanche remained with Monet and made the ultimate sacrifice of giving up her own painting in order to become her stepfather's housekeeper and companion. It was a difficult and often thankless task, which even Monet realized. "How kind she is, and how maddening I must be to everyone," he confessed once. As the artist went through every stage of discouragement,

The large studio or "Atelier aux Nymphéas," which in fact was Monet's third studio in Giverny. Measuring 72 x 39 feet, the immense, barnlike structure served its practical purpose well enough but left Monet in despair over its mammoth ugliness.

opposite: Monet following his cataract operation in 1923. Thanks to surgery, the eighty-three-year-old artist recovered more or less normal vision, which enabled him to continue painting for the rest of his life.

poor Blanche would have to inform the kitchen of the master's latest whim, that he wanted this or did not want that, or had decided to eat no lunch at all. The more unapproachable Monet became, the more everyone went to Blanche. Even Clemenceau wrote directly to her, whom he called "Monet's blue angel": ". . . since our dauber has been good enough to bestir himself, we should do him the favor of letting him work. When he has something to say, we shall be there to listen. In the meantime, keep him shut up. Love to both of you."

To the end, Blanche had the patience to tolerate her stepfather's demands, his terrible tantrums, his extreme anxieties, the years of the war, the cataracts, and the panels for the *Decorations* commissioned for the Orangerie. She always accompanied Monet to his painting site and, as in the days of old, carried his equipment, changed the canvases on the easel as the light itself changed, and then returned to her household duties. Even when things were going well enough, the pair never stopped bickering—about painting, the weather, etc.—none of which, however, would prevent Monet, a few minutes later, from interrupting his work to make a comment that sent them both into gales of laughter.

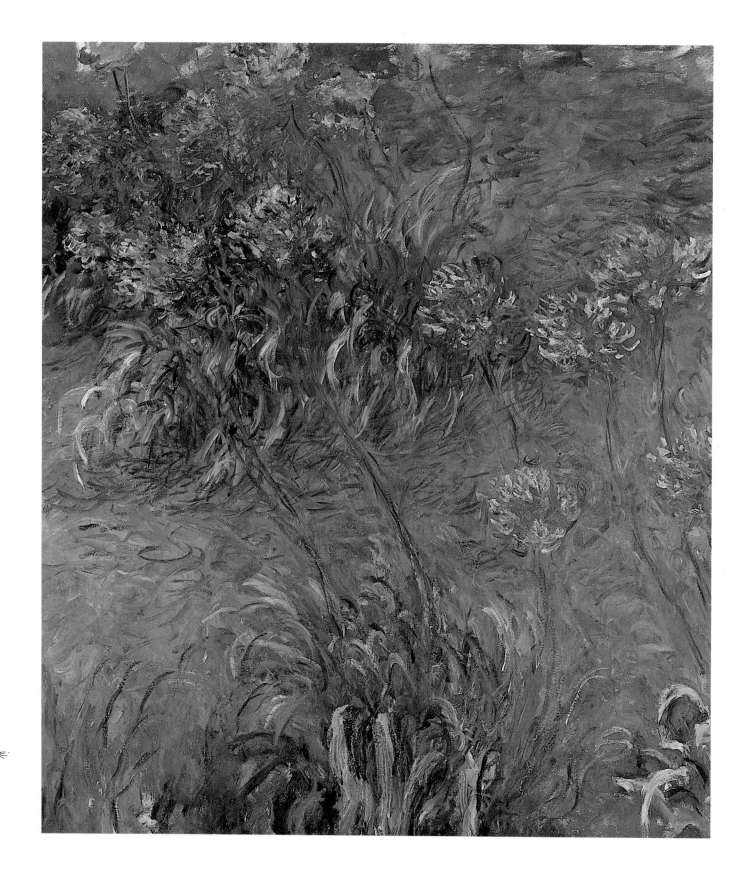

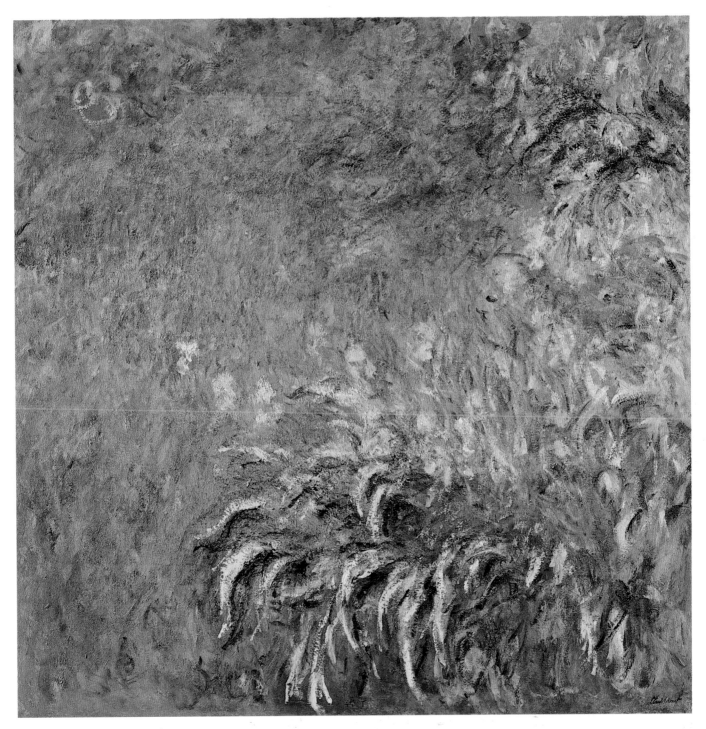

opposite: *Agapanthes* (Blue Waterlilies).
c. 1920. 6'6" x 5'10" (200 x 180cm).
Private collection, New York.

above: *Iris au Bord de l'Étang* (Iris at the Side of the Pool).
c. 1919. 6'7" x 6'7½" (200.5 x 202cm).
Art Institute of Chicago.

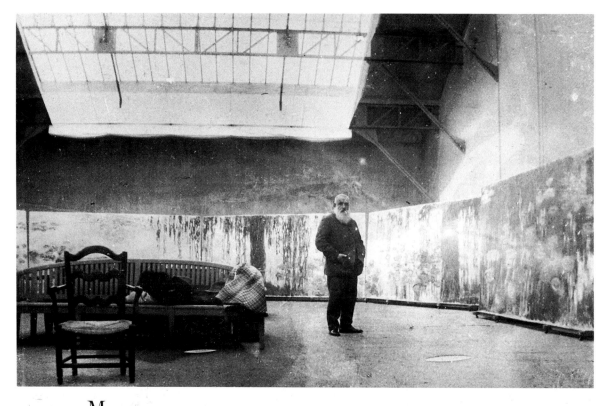

Monet in the oversized studio specially built for the huge waterlily "decorations" the artist wanted to present to France for installation in two oval halls at the Orangerie in the Tuileries Gardens. Begun in 1914, the structure was completed in 1916 and inaugurated by the Académie Goncourt following a dinner given by Monet.

opposite: In the large studio Monet, for relaxation, sometimes turned away from his waterlily project and painted other subjects. Here, with Germaine and Blanche, he stands in front of the mirror used for his self-portrait.

After dinner, someone trying to check on things would timidly peek inside the salon-atelier, only to find Monet and Blanche playing backgammon together.

When war broke out Jean-Pierre and Geneviève left for Périgord, while the Butlers were already safe in the United States. Monet had the sadness of seeing his family break up and scatter. Finally, Michel, Jean-Pierre, and Albert Salerou were all called up. Monet now lived in anticipation of the daily post. He worried about everybody, and, not daring even to inquire of Renoir about his old friend's son, he wrote to Durand-Ruel. Mme Renoir had collapsed and died when word arrived that her son had been injured. Nor was Michel Clemenceau spared. At Giverny, Monet and Blanche, cut off from everything and everyone, could only wait it out. The village's "Pilotis" were requisitioned and transformed into a hospital. At night cannon fire could be heard all the way from Beauvais, as an endless cortege of stretchers passed along the Chemin du Roy bearing the wounded back from the front lines. Monet followed the armies' movements on a map and resolved never to leave his domain, although at one dangerous moment he considered storing the collection away for safekeeping. Clemenceau, once again Prime Minister of France, made regular tours of the front and sometimes took the road to Giverny. There he found Monet unable to concentrate on painting. To help the artist by rekindling his interest in work, Clemenceau persuaded him to revive a project already considered and abandoned a hundred times: a series of grandly scaled *Water Landscapes* con-

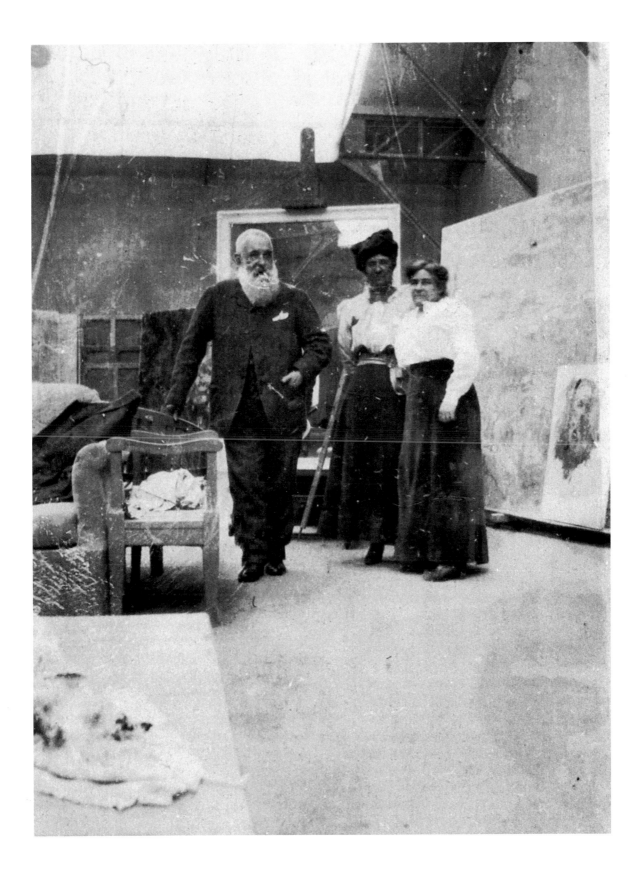

Le Pont Japonais (The Japanese Bridge). 1923–25.
35⅛ x 45¾″ (89.5 x 116.5cm).
Minneapolis Institute of Arts (bequest of Putnam Dana McMillan).

La Maison de Giverny (The House, Giverny).
c. 1922. 31⅝ x 35⅞″ (81 x 92cm).
Musée Marmottan, Paris.

ceived more as a decorative continuum than as mural paintings.

And so at the height of the war, when manual labor could scarcely be found, Monet decided to build a third studio, this one, at 39 by 75 feet, even larger than the others, and to crown its 49-foot height with a huge north-south skylight. Along with the skylight he also installed a system of awnings designed to filter and control the flow of light and thus simulate the luminary conditions of the pond. Finished in 1916 and inaugurated following a dinner arranged by the members of the Académie Goncourt, the studio nevertheless disappointed Monet by its massiveness. Writing to Jean-Pierre, he confessed to shame for having allowed "that ignoble thing" to be put up, he who had always been the first to oppose construction projects likely to disfigure the site.

Monet had already been working on his water-garden motifs for more than two decades, and he

Islands of white and blue agapanthus waterlilies floating on the sheetlike surface of Monet's pond.

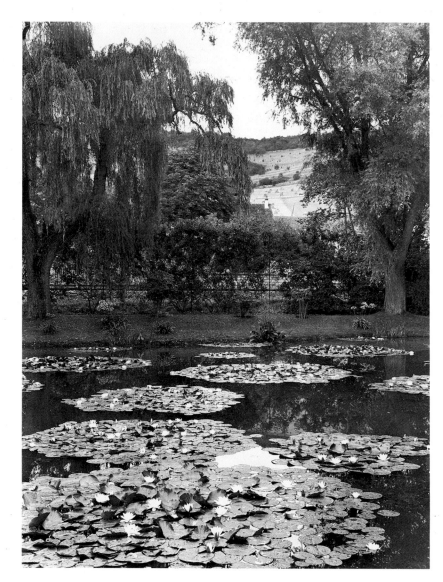

envisioned many more years of labor before the new project could be realized to his satisfaction. Instead of approaching his theme piecemeal, picture by picture, he felt ready to attempt a representation of the lily pond as a whole. For the exhibition of the work, he wanted a novel kind of building, circular in form and completely glazed overhead. Eager for the series to belong to the nation, he considered the work not as a commission but rather as a gift that he hoped to make to France. After countless deliberations, Monet would agree to have the paintings installed at the Orangerie in the Tuileries Gardens, and not in a single circular room but in two oval-plan spaces, an arrangement that presented the artist with problems of format.

The Large Decorations became the subject of endless bureaucratic foot-dragging as well as vague hesitations on the part of the artist, with the result that the final installation was not inaugurated until 1927, the year after Monet's death.

They also brought Monet and Clemenceau to the brink of a serious quarrel. For a long while there was no written agreement concerning the decorations. Still, Clemenceau, a man of infinite trust and patience, had proceeded to gain official acceptance for all the conditions set by Monet. Thus, considerable money had been spent to have the two rooms at the Orangerie rebuilt. The arrangement respected all of Monet's many wishes, which he expressed in endless detail. And so he should have, given the fact that he was painting the pictures from a particular point of view, which could have its impact only if the final work was exhibited as planned by the artist, who left nothing to chance—format, the flat, somewhat Japanese conception of space, the effects of light and depth. Together, the series would invite viewers to join the artist in a tour of the water garden, a fact that made it important to consider the height from which the eye would fall upon the nympheas.

The architect had his work cut out for him, but, finally, on April 12, 1922, the act of donation was signed and witnessed by a notary in Vernon. Having resolved all the conflicts, Clemenceau was overjoyed. Alas, he had not taken account of the extent to which Monet could lose heart and find himself, on several occasions, overwhelmed by his own undertaking. And when Clemenceau arrived to check on the project, he was appalled to discover how much the cataracts had affected the artist's vision. Instead of perfecting his work, Monet, by his obsessive retouching, risked destroying the whole. In 1923, he underwent an operation, after which it was long before he regained anything like normal vision. Meanwhile, the artist was aging rapidly. One day, in a fit of despair, he threatened to destroy his work and start afresh, or indeed give up the project as hopeless. Monet took a different tack every time Clemenceau appeared, and he even considered compensating the state by giving all or part of his personal collection. When he wrote Clemenceau declaring this to be his intention, the old statesman finally blew up. It had been difficult enough for him to justify all the delays, and now Monet wanted to renege. Clemenceau replied that however great his discouragement, Monet simply could not, under any circumstance, go back on his word. As usual, Clemenceau counted on Blanche to bring the artist round, as he wrote to her on January 7, 1925:

My dear friend
I have received a shocking letter from Monet, and I won't stand for it. By this same post he will get my answer, which you will probably find very harsh, but which is absolutely sincere.
 If he does not alter his decision I will never see him again.

 G. Clemenceau

Finally, Clemenceau and Blanche had their way with the difficult genius, and everything related to the troubled series fell into place. But what an extraordinary notion it was to create a lily pond in order to paint a series of pictures in a studio designed precisely for that purpose, and then to build a special museum to house the series.

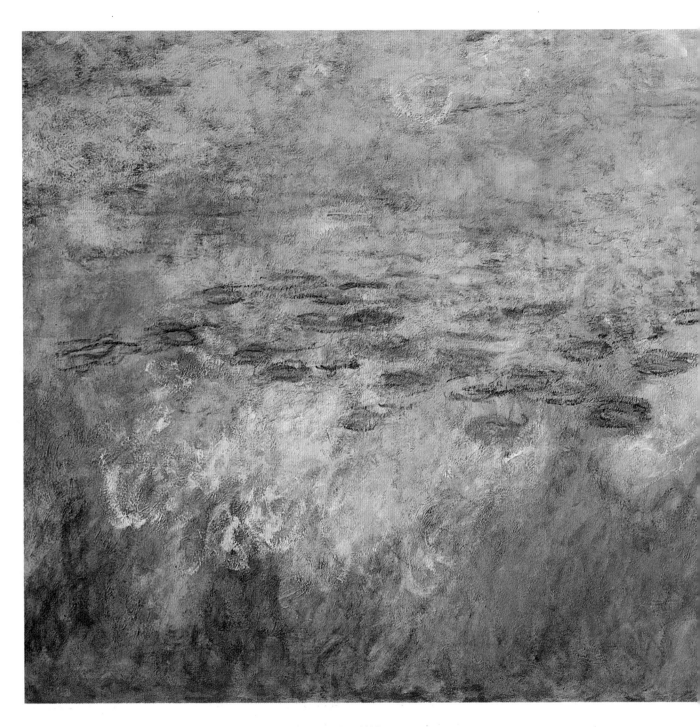

Nymphéas (Waterlilies). c. 1920.
6'6" x 14' (200 x 426cm). Central panel of a triptych.
Museum of Modern Art (Mrs. Simon Guggenheim Fund),
New York.

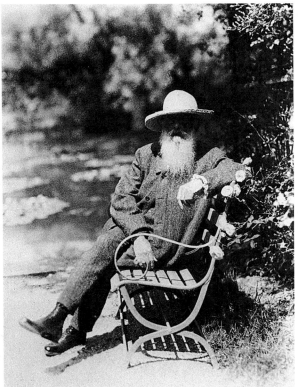

above:
Monet's friend, the horticulturist Georges Truffaut, casting a connoisseur's admiring eye over the Japanese peonies in the water garden.

right: Monet in June 1926, a few months before his death.

opposite above: Monet with his Primuline hybrid gladiola.

opposite below: The garden at its zenith in the 1920s. Norman thrift found slight place in this controlled horticultural exuberance.

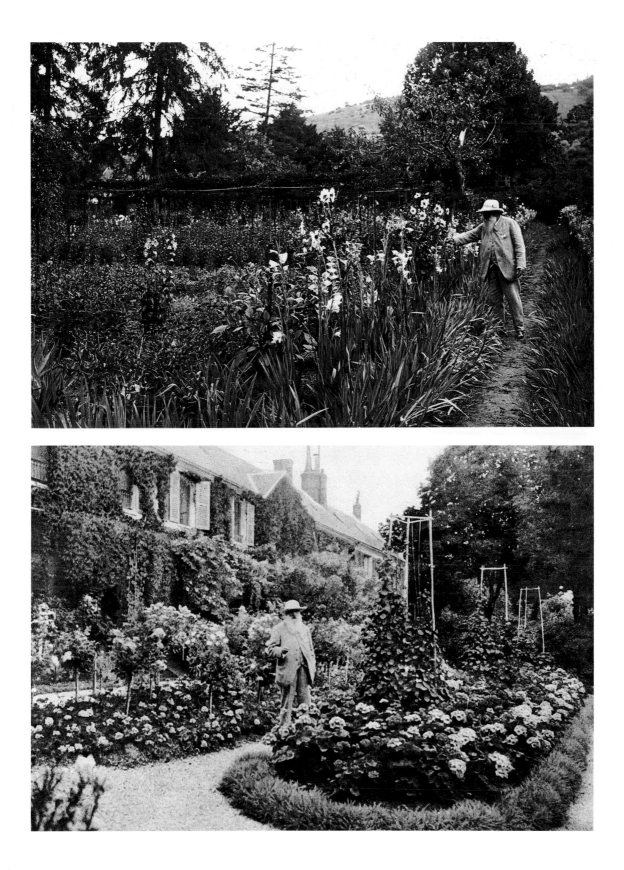

Nymphéas (Waterlilies). c. 1916–22.
6'2" x 19'6" (200 x 600cm).
Kunsthaus, Zurich.

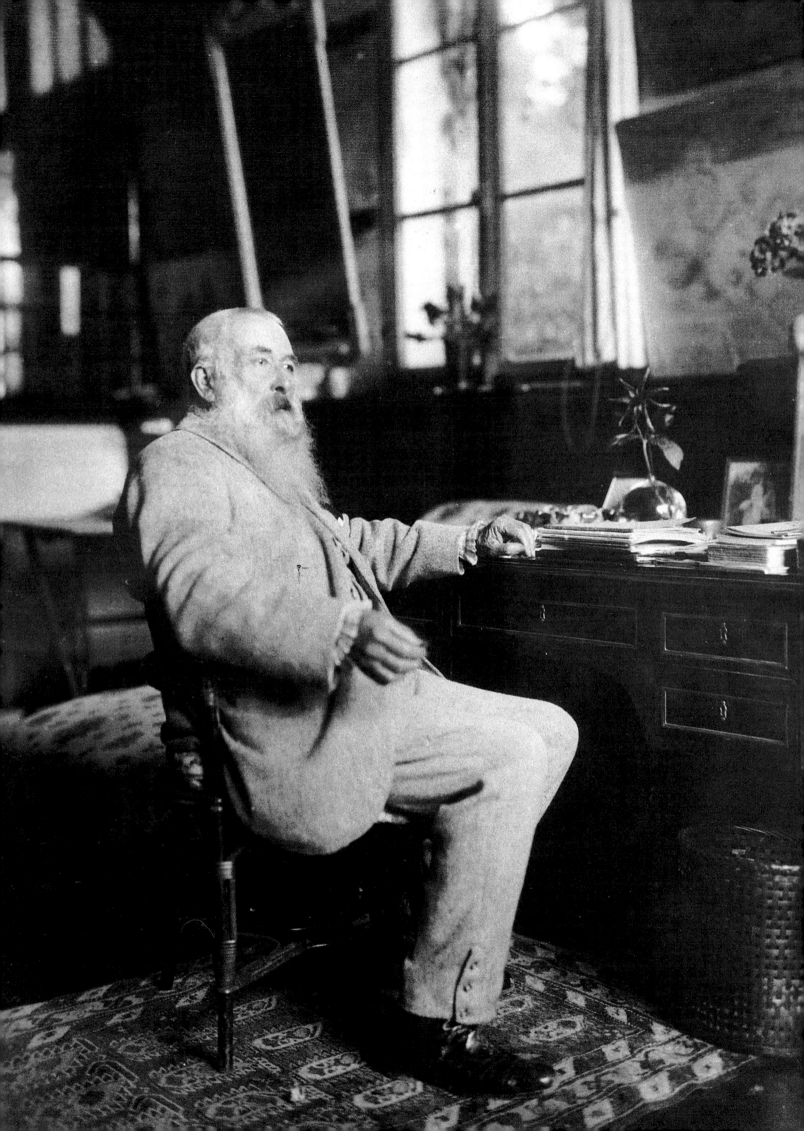

The Final Years

The war had driven away Giverny's colony of American artists. But having kept their houses, many of them would return from time to time right up to the Crash of 1929. By then, however, they had been largely succeeded by other artists, this time, however, writers more than painters. The Hart home had long since become a boarding house where actors, and even Isadora Duncan, stayed. Next the Surrealists discovered Giverny, spending weekends there with Teddy Toulgouat at the Ferme de la Disme—Breton primarily, but also Aragon, Michel Leyris, Drieu la Rochelle, Tristan Tzara, and many others.

Monet, meanwhile, simply continued along his own way. The Butlers had at last returned from America, and their return had been celebrated with a grand family dinner and gifts by Monet of his paintings. But no one could persuade the artist to accept either the Legion of Honor or a chair at the Institute. Had he foreseen what he took to be the "last hurrah" of a shattered civilization or recognized the face of a new, totally different world about to be born?

Monet outlived most of his friends—Renoir, Paul Durand-Ruel, Rodin, Degas, Mirbeau, Geffroy—and he would even outlive Marthe, who died in 1925.

Given his fascination with the exotic, why had Monet not gone to Japan, where he was often invited? He was equally unresponsive to the many invitations he received from the United States. The artist had spent sixty-eight years discovering Venice and Europe, but in the end he had seen only France, The Netherlands, Norway, the Italian Riviera and Venice, Madrid, London, Switzerland, and a few museums in Germany and Belgium.

Gradually, time robbed Monet of his quick and agile gait. When stricken with cataracts, he had exchanged his felt for a wide-brimmed panama. But he went on chain-smoking Caporal cigarettes. He was also as highstrung and anxious as ever, and his robust appearance of a country man accustomed to outdoor exercise gave way to a thin, drawn look. At the beginning of 1926 the signs of fatigue became inescapable and more frequent. At first seeing nothing serious in this, Clemenceau thought that his friend was merely suffering from a disease known as "old age." Albeit exhausted himself but forever the resolute optimist, Clemenceau went to Giverny as often as possible to keep Monet company and try recharging an old battery depleted from overuse.

When Clemenceau was about, Monet recovered his appetite a little. If he had not been outside for several days, the former Prime Minister would keep him in the garden for an hour or more. Eventually, however, the fact had to be faced, as the doctors diagnosed pulmonary sclerosis, complicated by long years of heavy smoking. Only one lung was functioning, and that not very well. Furthermore, the doctors ordered their patient to rest, which Clemenceau was persuaded would simply leave Monet depressed and thus accelerate his deterioration. Better that he remain active. To make matters worse, the two doctors attending the artist gave conflicting opinions. One predicted that he would succumb to a sudden and massive hemorrhage, while the other thought he might just linger for an indefinite time. Never suspecting the nature of his illness, Monet willingly went on receiving visitors.

Monet began painting once more, and although determined never again to touch *The Large Decorations*, he could not bring himself to part with them. He simply wanted to look at the series at his leisure. Knowing how little time remained, Clemenceau had the tact not to raise the subject again and to leave the artist in peace during his last months.

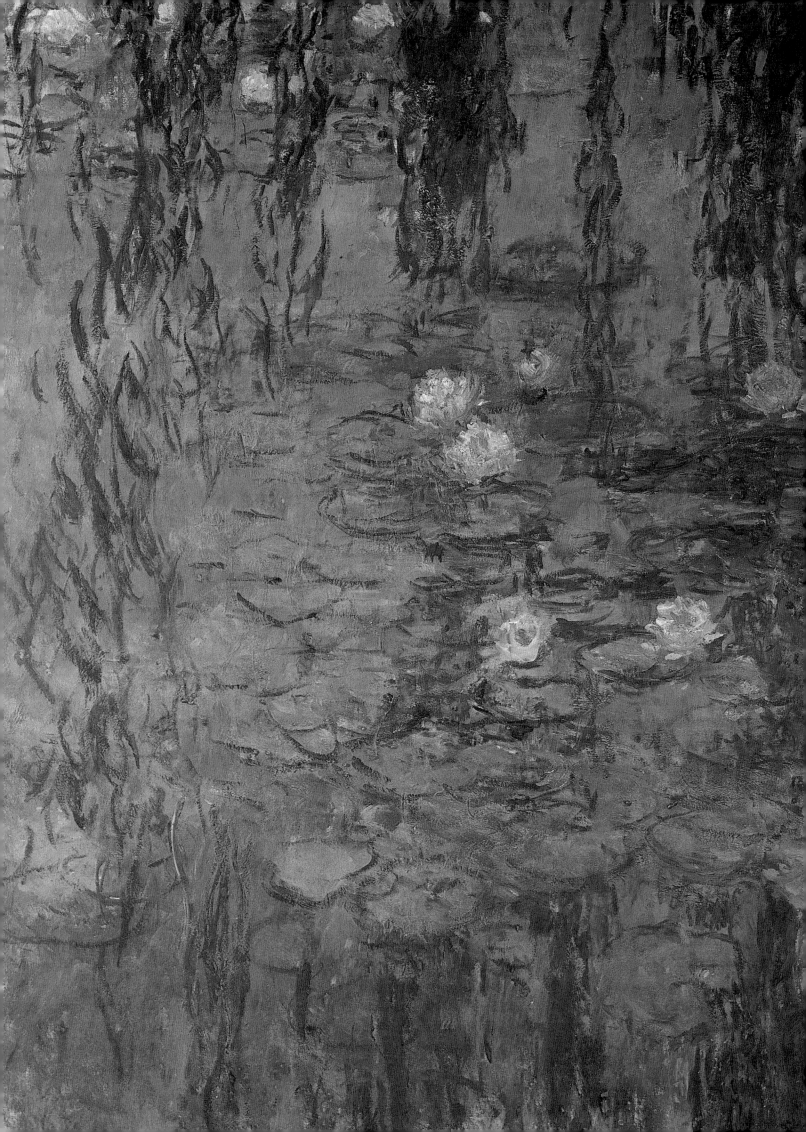

As Monet grew more feeble, he was shaken by the death of Mirbeau. The weddings of Lily and Sisi provided the last festivities the artist would attend, and he spent his final summer observing the lily pond seated on a bench. Sometimes his suffering was acute, but as soon as he felt better he recommenced working, despite orders to the contrary, and did not in fact abandon his brushes until autumn. Blanche and Michel never left his side. Bonnard came often and, with Thadée Natanson, visited Monet a mere fortnight before he died.

Clemenceau, who from the Vendée kept in touch with the doctors and Blanche by letter, decided to return to Paris on October 12 by way of Giverny, where he hoped to see for himself how the patient was faring. Alas, he found him considerably weakened and apparently even bereft of interest in painting, which had been his very reason for living. Monet spoke only of the garden and of the lily bulbs the Kurokis were to send him from Japan.

When the pain subsided at the end of November, it seemed a symptom of a will that had ceased to fight. On December 5 Clemenceau received a call and left early in the morning for Giverny. Toward midday Monet died quietly. Clemenceau, the former physician, closed his friend's eyes and said goodbye to Blanche and Michel.

Monet had wanted only a simple service, and he had it. At the request of Jean-Pierre the Prefect made no speech. Clemenceau waited at the graveside. As Monet's body was carried from the Maison du Pressoir his magnificent garden lay numb under the first winter frosts. The great man went to his resting place on the village's old hand-cart hearse, escorted by family, a crowd of villagers, as ancient custom dictated, and a few friends—Bonnard, Vuillard, Roussel, Natanson—who had not heard of their dead friend's wish to be buried in the strictest privacy.

Without a eulogy, the service was minimal and brief in the extreme. It consisted merely of flowers, loved ones, and friends. Then Clemenceau said: "Come along, children; we must be off!" With that, he returned to the waiting car and made his way back to the Rue Franklin.

Monet's silhouette reflected in the water, as the artist prepared to photograph his waterlilies.

opposite: *Nymphéas Bleus* (Blue Waterlilies). c. 1917. 6'2" square (200 cm sq.). Collection E. Tériade, Paris.

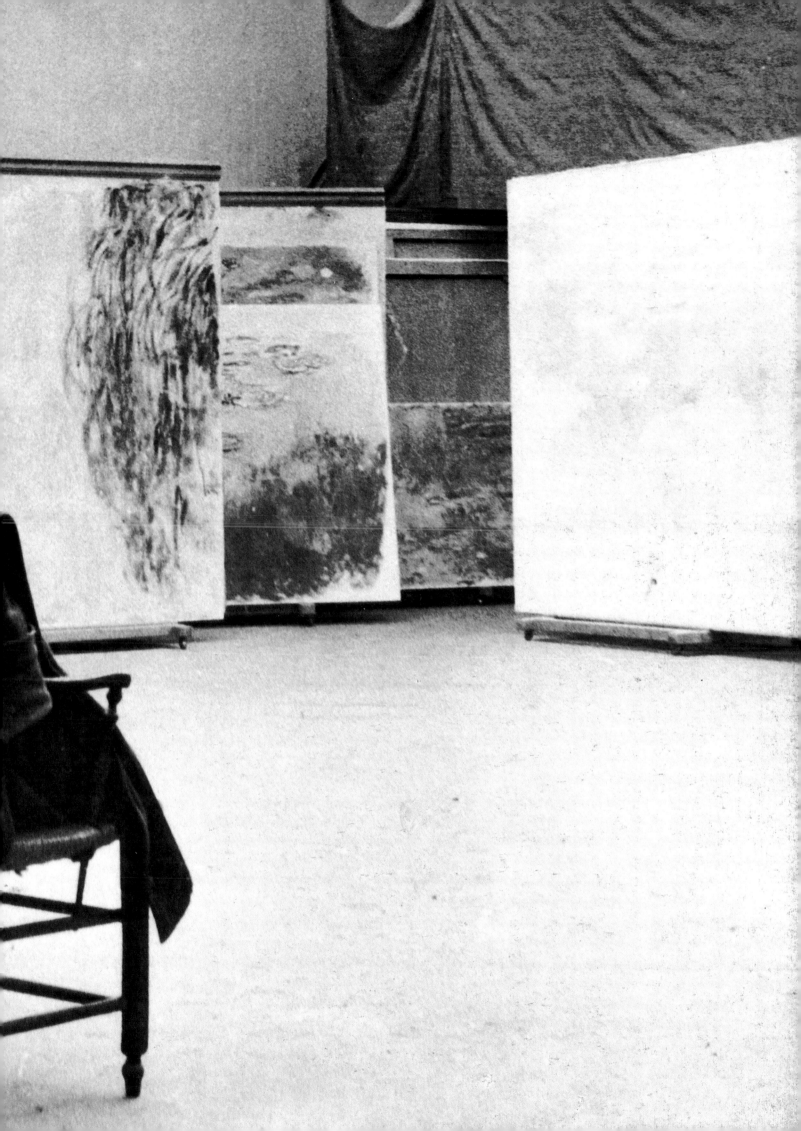

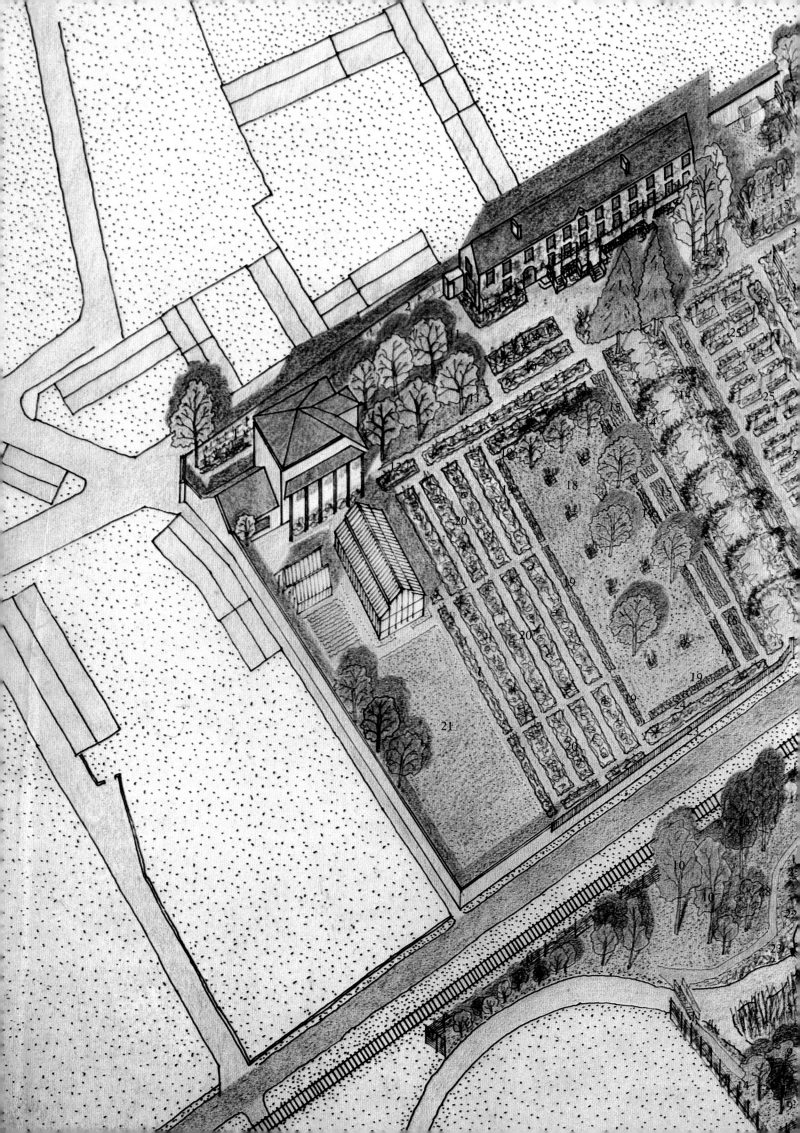

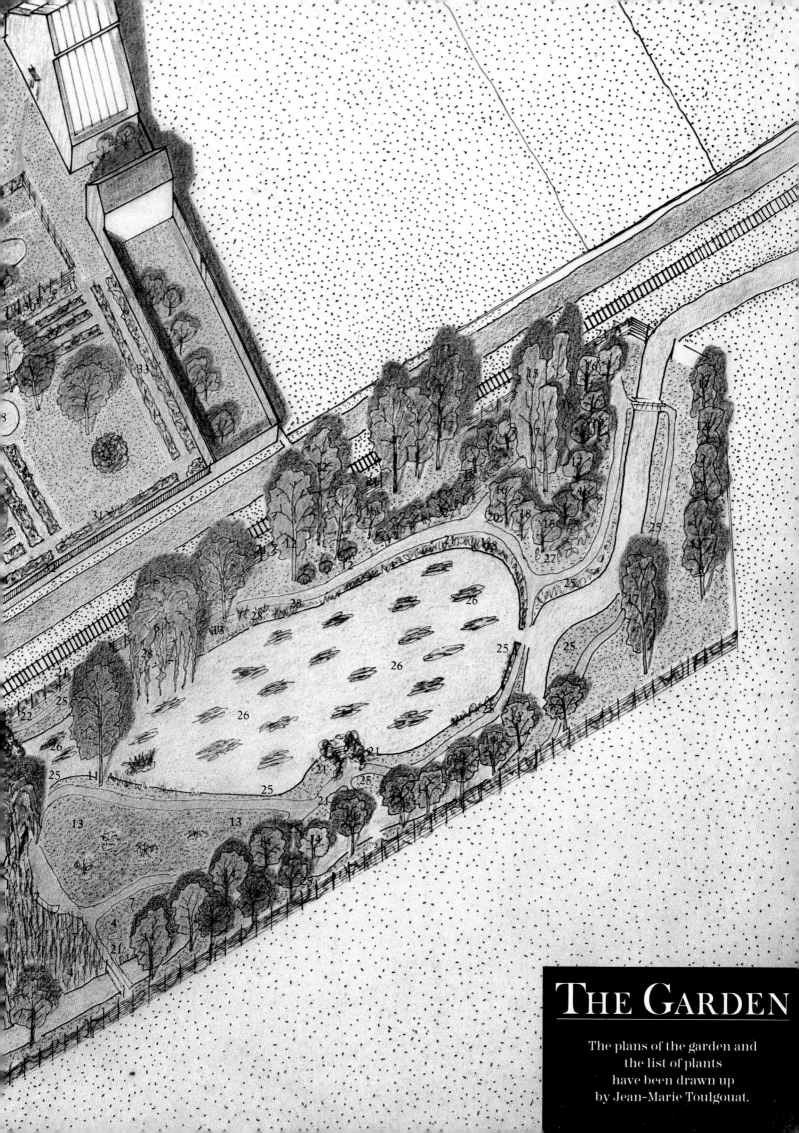

THE GARDEN

The plans of the garden and
the list of plants
have been drawn up
by Jean-Marie Toulgouat.

The Flower Garden

The drawing on the preceding two pages shows the positions
of the principal plants in Claude Monet's garden as listed below by season.

Spring

1 Yellow winter jasmine on the wall close to the gate. Maple sycamore tree. Snowdrops. White Christmas roses. Primulas. Mauve and violet Irises germanica. Pink peonies.
2 Border of aubrietias. Snowdrops. White Christmas roses. Primulas. Mauve and violet Irises germanica. Pink peonies.
3 Border of aubrietias. Primulas. Pansies. Viola cornuta. Irises germanica.
4 Border of aubrietias. Primulas. Pansies. Viola cornuta. Snowdrops.
5 Border of aubrietias. Crocus. Jonquils. Viola cornuta. Irises germanica.
6 Snowdrops. Christmas roses. Primulas. Jonquils. Syringas. Viburnums.
7 Border of aubrietias. Snowdrops. Jonquils. Tulips.
8 Border of aubrietias. Snowdrops. Jonquils. Tulips.
9 Border of aubrietias. Snowdrops. Jonquils. Tulips.
10 Border of aubrietias. Snowdrops. Jonquils. Tulips.
11 Lime trees. Snowdrops, Primulas.
12 Border of Irises germanica. Jonquils. Tulips.
13 Border of Irises germanica. Jonquils. Tulips.
14 Yard-wide borders of Irises germanica. Dutch irises. Oriental poppies. Peonies. Pansies. Doronics. Columbines. Primulas.
15 Border of Irises germanica. Jonquils.
16 Irises germanica.
17 Border of Irises germanica. Jonquils.
18 About 12 5-foot square places in the green with border of Irises germanica. Jonquils. Peonies. Japanese cherry trees. Japanese apple trees. Japanese maple trees. Oriental poppies.
19 Border of Irises germanica. Jonquils.
20 Border of aubrietias. Jonquils. Tulips ordered by colors (red, yellow, pink, rose and parrot tulips). Columbines.
21 Green. Horse-chestnut trees.

22 Border of Irises germanica. Doronics.
23 Border of Irises germanica. Doronics.
24 Border of Irises germanica. Doronics.
25 Border of aubrietias. Jonquils. Clematis. Leopard's banes. Tulips ordered by colors (red, rose, pink, yellow, parrot tulips).
26 Jonquils. Columbines.
27 Jonquils. Columbines.
28 Pond.
29 Irises germanica.
30 Border of aubrietias.
31 Irises germanica.
32 Border of irises germanica. Doronics.
33 Border of aubrietias. Clematis.

Summer and Autumn

1 Japanese anemones (white and pink). Cactus dahlias. Maple sycamore tree.
2 Japanese anemones (white and pink). Mauve asters. Border of Campanula carpatica. Passion flower climbing on the wall of the central heating. Dahlias (yellow, white and pink).
3 Border of Campanula carpatica. Climbing roses and rose trees with simple flowers (pink, yellow, orange). Rudbeckias. Virginia creeper on the house.
4 Border of Campanula carpatica. Climbing roses and rose trees with simple flowers (pink and red). Clematis. Sages. Virginia creeper on the house.
5 Border of Campanula carpatica. Climbing roses. Pot marigolds. Aconitums. Pinks.
6 Japanese anemones (white and gold).
7 Border of pinks. Red pelargoniums. Cannas. Sages.
8 Border of pinks. Red pelargoniums. Cannas. Sages.
9 Border of Campanula carpatica. Red pelargoniums. Pinks.
10 Rose trees with red flowers. Pelargoniums. Sages. Japanese anemones. Clematis. Morning glories.
11 St. John's worts. Lime trees.
12 Climbing roses. Clematis. Morning glories. Snapdragons. Cactus dahlias, simple flowers.

13 Climbing roses. Clematis. Morning glories. Snapdragons. Cactus dahlias with simple flowers.
14 Creeping nasturtiums. Climbing roses with simple rose and crimson flowers. Sunflowers. Cone flowers. Daisies. Asters (white, pink, violet). Delphiniums. Bellflowers. Cactus dahlias.
15 Climbing roses. Asters. Sunflowers. Foxgloves.
16 Delphiniums. Cone flowers. Daisies.
17 Morning glories. Clematis. Japanese anemones. Snapdragon. Bellflowers.
18 Japanese anemones. Asters. Cactus dahlias.
19 Climbing roses with simple flowers. Asters. Cacuts dahlias.
20 Border of pinks. Evening primroses. Daisies with white flowers. Heliopsis. Willow herbs. Snapdragons. Delphiniums. Mulleins. Pot marigolds. Cone flowers. Gladiolus by colors. Cactus dahlias.
21 Green. Horse-chestnut trees.
22 Japanese anemones. Nasturtiums climbing on the enclosure along the road.
22 Japanese anemones. Nasturtiums climbing on the enclosure along the road. Pot marigolds. Bellflowers. Mulleins.
24 Japanese anemones. Summer clematis. Snapdragons. Asters. Pot marigolds.
25 Snapdragons. Daisies. Pinks. Bellflowers. Summer clematis. Cactus dahlias. Dead man's fingers.
26 Lilies. Gladiolus. Foxgloves. Monkshoods.
27 Foxgloves. Monkshoods. Blue thistles.
28 Pond. A pair of pink sumacs close to the pond.
29 Japanese anemones. Pinks.
30 Pinks. Monkshoods.
31 Japanese anemones. Snapdragons.
32 Japanese anemones. Nasturtiums climbing on the enclosure along the road. Bellflowers.
33 Sweet peas. Goldenrods.
34 Blue hydrangeas. A maple sycamore tree.

The Water Garden

	Plant	Season
1	Japanese quince tree	Spring
2	Raspberry bush	
3	Bamboos	
4	Bamboos	
5	Petasites (sweet-scented coltsfoot)	
6	Weeping willow	
7	Black bamboos	
8	Wisteria: mauve and	Late spring
9	Japanese cherry tree	Late spring
10	Alder tree	
11	Ash tree	
12	Willow	
13	Peony bush	Late spring
14	Japanese apple tree	Spring
15	Azaleas	Spring
16	Rhododendrons	Spring and summer
17	Poplar	
18	Fern	
19	Ginkgo	
20	Barberry	
21	Rose tree	Summer
22	Lilies	Summer
23	Solomon's seal	
24	Pampas grass	
25	Irises	Spring
26	Waterlilies	Summer
27	Holly tree	
28	African lily	Summer
29	Tamarisk	

GIVERNY
TODAY

A Photographic Album
by John Batho

137

Acknowledgments

I wish to express my warmest thanks to Monsieur Charles Durand-Ruel and to Monsieur Gruet, who not only allowed me complete freedom to use the Durand-Ruel archives but also offered much welcome advice concerning those invaluable resources. I wish also to extend my thanks to Professor John Rewald, Madame Simone Salerou-Piguet, Messieurs Marc and Philippe Piguet, Monsieur Le Flour and Monsieur Fuchs of the Truffaut archives, Madame Marguerite Lavenu, Monsieur Pierre Toulgouat, Madame Renée Arrous, and Monsieur Le Gal and Monsieur Lecointe, two of the surviving gardeners who worked at Giverny during Monet's lifetime. Above all, I wish to acknowledge how deeply indebted I am to the late James P. Butler, whose command of Japanese art and botany as well as whose detailed recollection of the garden and rituals of the Monet household, where he grew up, made this book possible. I am especially grateful to Françoise and Anne Joyes for their deep understanding throughout all the many stages that made up the preparation of *Claude Monet: Life at Giverny*. Finally, the publishers join me in thanking Gérald van der Kemp and Barnabas McHenry for their enthusiasm and support.

CLAIRE JOYES
Giverny
June 1985

*Unless otherwise noted, the medium used by Monet
in painting the pictures reproduced here is oil on canvas.*

Chronology

1840 Monet born in Paris on November 14, the year that Auguste Rodin was also born. Adolescence spent in Le Havre, where he won early recognition for his caricatures of leading Havrais citizens.

1858 Meets the marine painter Eugène Boudin, who persuades young Monet to work in oil and paint *plein-air* motifs.

1859 –61 Leaves Le Havre for Paris, but remains in touch with Boudin. Frequents the Brasserie des Martyrs, where he sees Courbet for the first time. Attends painting sessions at the Académie Libre Suisse, and there meets Pissarro.

1861 –62 Monet does military service in Algeria, from which he is relieved for reasons of health. Meets the Dutch marine painter Jongkind. Monet senior allows Claude to return to Paris on condition that he attend classes at a studio where he will receive instruction from a professor at the École des Beaux-Arts. This takes him to the Atelier Gleyre, where he makes friends with Bazille, Renoir, and Sisley.

1864 Meets Courbet, and leaves the Atelier Gleyre to paint in the Fontainebleau Forest with Bazille, Renoir, and Sisley.

1865 Shares a studio in Paris with Bazille. Exhibits two marine paintings at the Salon. Paints *Luncheon on the Grass.*

1866 With some success, Monet exhibits at the Salon a portrait of Camille Doncieux, who would become his first wife.

1867 *Women in the Garden* refused by the Salon. A son, Jean, born to Claude and Camille, who are in severely straitened circumstances.

1868 Monet has only one painting accepted at the Salon, even as his financial worries increase. Bazille's plans for an exhibition separate from the official Salon fall through for the want of money.

1869 Works submitted by Monet to the Salon are refused.

1870 Once again suffers rejection by the Salon. Marries Camille Doncieux. Leaves for England at the outbreak of the Franco-Prussian War. In London, makes contact with Pissarro, who introduces him to Paul Durand-Ruel. Discovers and studies the art of Constable and Turner. Bazille killed in the war.

1871 Monet in Holland before returning to France.

1872 Settles in Argenteuil, where Renoir joins him.

1873 Monet meets Gustave Caillebotte. Builds a boat-studio based on the model of Daubigny's *Bottin.*

1874 In the studio of the photographer Félix Nadar, Monet and Pissarro organize the first of the eight Impressionist exhibitions.

1876 Monet makes his first visit to the Château de Rottembourg, at Montgeron, where Ernest and Alice Hoschedé have their country home. The Hoschedés commission the artist to paint the *Montgeron Decorations.*

1877 Courbet dies, and Ernest Hoschedé slips into bankruptcy.

1878 Sale and dispersal of the Hoschedé estate and collection. Alice Hoschedé, with her six children, makes a common household with the Monets in the village of Vétheuil. Michel Monet, a second son, is born to Claude and Camille.

1879 Camille Monet dies. Mme Hoschedé takes charge of the upbringing and education of Monet's two sons, along with her own brood of six.

1880 Series of debacles at Vétheuil, flooding among them. Monet makes a painting trip along the cost of Normandy.

1881 Monet again paints along the Normandy coast. The Monet-Hoschedé household leaves Vétheuil for Poissy.

1882 While living at Poissy, the Monets and the Hoschedés sojourn at Pourville on the Channel coast.

1883 Monet makes painting trips to Étretat and Le Havre. Has his first one-man exhibition, presented by Paul Durand-Ruel. Leaves Poissy and takes a large house at Giverny. Manet dies. Monet and Renoir travel together to the South of France and along the Italian Riviera.

1884 Painting trip to Bordighera and Menton on the Mediterranean coast. Shows in the International Exihition.

1885 Shows at the Georges Petit Gallery. Another painting trip to Étretat.

1886 Monet again shows with Georges Petit, but quarrels with Durand-Ruel over the dealer's attempt to sell Impressionist paintings in the United States. Makes a painting journey to The Netherlands, and exhibits with Les XX in Brussels. During a sojourn at Belle-Île in Brittany, he meets Gustave Geffroy, who puts the painter back in touch with Georges Clemenceau. Monet visits Mirbeau at Noirmoutiers.

1888 New quarrels with Durand-Ruel over the latter's American venture. Consigns some paintings to Boussod and Valadon. A working sojourn in Antibes.

1889 The joint Monet-Rodin exhibition staged by Georges Petit a rousing success. Monet paints in the Creuse, where he sees much of Maurice Rollinat and his wife. Organizes a subscription to purchase Manet's *Olympia* for the Louvre.

1890 Works mainly at Giverny, there continuing
–91 his series of *Haystcks*. Purchases the Giverny house, and makes up with Durand-Ruel.

1891 Exhibits *Haystacks* with Durand-Ruel. Journey to London. Ernest Hoschedé dies and, although separated from his family since the bankruptcy, is buried at Giverny.

1892 Monet stays in Rouen to work on his *Cathedral* series. Exhibits the *Poplars* at Durand-Ruel's. Marries Mme Alice Raingo Hoschedé.

1893 Monet creates the lily pond and water garden. Berthe Morisot and Caillebotte die.

1894 Mary Cassatt and Paul Cézanne visit Giverny.

1895 Monet visits Norway. Durand-Ruel exhibits twenty canvases from the *Cathedral* series. The painter launches upon his *Waterlily* series.

1896 A new stay at Pourville.

1897 *Cathedrals* exhibited in Venice.

1898 Stéphane Mallarmé dies.

1899 Alfred Sisley and Suzanne Hoschedé Butler die. Monet continues working on the *Waterlily* pictures.

1900 In London for the *Thames* series.

1901 Again in London to paint. Monet does another series at Vétheuil. Rebuilds the waterlily pond.

1902 Exhibits *Waterlilies* at the Bernheim-Jeune Gallery. Works on the *Thames* pictures in Giverny.

1903 Pissarro dies. New *Thames* pictures.

1904 *Thames* paintings shown by Durand-Ruel. Monet and Alice visit Spain to see the works of Velázquez in the Prado. A new sojourn in London.

1905 New *Thames* series.

1906 Cézanne dies.

1908 Monet makes his last painting trip to Venice. Suffers the first cataract symptoms.

1909 Exhibits a new series of *Waterlilies*. Alice Monet falls ill.

1911 Oversees the last campaign to enlarge the lily pond. Alice Monet dies.

1912 Exhibits in Venice. Meets Pierre Bonnard.

1913 Monet travels in Switzerland with his family.

1914 Jean Monet, the artist's elder son, dies. Monet has the large studio (the "Atelier aux Nymphéas") built to accommodate his work on *The Large Decorations* planned as a gift to the French state.

1916 Inauguration of the Atelier aux Nymphéas.

1917 Mirbeau, Rodin, and Degas die.

1919 Renoir dies.

1922 Paul Durand-Ruel dies. Monet signs the documents donating *The Large Decorations* to the state.

1923 Undergoes surgery for the removal of his cataracts.

1926 Gustave Geffroy dies, as does Claude Monet, on December 5.

Bibliography

Bang, Hanri. *Extraits de Journal*, trans. from Norwegian by Jacques Hoschedé. 1895.

Breuil, Félix. "Les Iris aux bords des eaux," *Jardinage*, October 1913, No. 21.

Dufwa, Jacques. *Winds from the East*. Stockholm, Almqvist et Wiksell International, 1981.

Geffroy, Gustave. *Claude Monet: sa vie, son oeuvre*. Paris, G. Crès et Cie, 1924.

Hoschedé, Jean-Pierre. *Claude Monet, ce mal connu*. Geneva, Cailler Éditeur, 1960.

Isaacson, Joel. *Observation and Reflection: Claude Monet*. Oxford, Phaidon Press, 1978.

Le Gal, Albert. *Journal: 1910–1916*.

Monet, Alice. *Journal: 1863–1910*. Archives Toulgouat-Piguet.

Monet, Blanche. *Notes sur Claude Monet*. Archives Toulgouat-Piguet.

Perry, Lilla Cabot. "Reminiscences of Claude Monet from 1889 to 1909," *American Magazine of Art*, Vol. XVIII, March 1927, No. 3.

Raingo-Pelouse, Pierre. *Généalogie de la famille Raingo*.

Rewald, John. *The History of Impressionism*. N.Y., Museum of Modern Art, 1961.

Toulgouat, Pierre. "Peintres américains à Giverny," *Rapports France-Etats-Unis*, No. 62, May 1952.

Toussaint, Abbé Anatole, and Jean-Pierre Hoschedé. *Flore de Vernon et de La Roche-Guyon*. Rouen, Julien Lecerf, 1898.

Truffaut, Georges. "Le Jardin de Claude Monet," *Jardinage*, November 1924, No. 87.

Venturi, Lionello. *Les Archives de l'Impressionisme*. Paris-New York, Durand-Ruel Éditeurs, 1939.

Photographic credits

(*cited by page number*)

Country Life: 94; Durand-Ruel: 33, 60, 80, 105, 117 (below); Michel Guillard; 8, 9, 12, 13, 23, 89; Musée Claude Monet: 65, 68 (below), 72; Piguet: 1, 10, 14, 25, 32, 36, 40 (below), 44, 58, 82, 83, 87, 88, 95, 104, 105, 108, 109, 112; Toulgouat: 17, 21, 22, 23, 24, 28, 29, 41, 43, 48, 49, 51, 56, 57, 69, 76, 83, 86, 97; Truffaut: 40 (above), 90, 96, 100, 101, 102, 116 (above), 117 (above).